THE
ART
OF
THE
WE...
WOMI...

Acknowledgements

We would like to express our gratitude to:

The Federal State Office of North-Rhine-Westphalia, especially Frau Ilse Ridder-Melchers, the Minister of Equal Opportunities for Men and Women of the Federal State of North-Rhine-Westphalia, Germany, for their very generous sponsorship of *The Art of the Weya Women.*

(Staatskanzlei des Landes Nordrhein-Westfalen, insbesondere Frau Ilse Ridder-Melchers, Ministerin für die Gleichstellung von Mann und Frau des Landes Nordrhein-Westfalen, für die großzügige Unterstützung von *The Art of the Weya Women.*)

The Deutscher Entwicklungsdienst (German Volunteer Service) and the Friedrich-Ebert-Stiftung (Zimbabwe) for their consistent support and encouragement.

The Weltfriedensdienst (community services) for their support of the Weya training programme and for the photographs on pages 10, 11, 35, 137, 140.

We would also like to thank Christoph von Haussen for taking the photographs on pages 14, 15, 17, 20, 27, 32, 34, 36, 43, 45, 46, 47, 49, 53, 54, 56 ,57, 66, 69, 72, 73, 78, 79, 82, 84, 85, 88, 89, 103, 107, 110, 111, 116, 120, 121, 125, 128, 142, 143, 155, 158, 159, 161, 162, 163, 168, 169, 174, 175, 177, 180, 181, all other photographs appearing by kind permission of Duplex Repro and Calvin Dondo for the photographs of the Weya women on pages 4 and 5.

We also owe our gratitude to Agnes Shapeta for her invaluable assistance in the Weya training programme and for her help with the interviews and with the local historical and cultural background.

Published by: Baobab Books, P.O. Box 1559, Harare, Zimbabwe, 1992

© Ilse Noy, 1992

Cover: Tali Geva-Bradley
Design: Tali Geva-Bradley
c/o Jafta Cards, P O Box A595, Avondale, Harare

Edited by: Virginia Tyson

Typeset by: SIR Publications

Page Film produced by: University of Zimbabwe Publications

Colour separations by: Colorscan (Pvt) Ltd

Originated by: Lucas Origination, Harare

Printed by: Mazongororo Paper Converters, Harare

ISBN O - 908311 - 50 - 8

HE
ART
OF
THE
WEYA
WOMEN

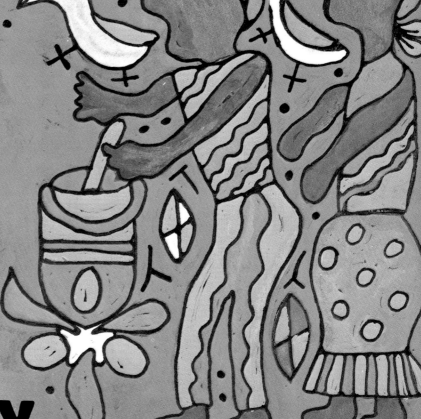

BAOBAB BOOKS

LSE NOY

THIS
BOOK
IS
DEDICATED
TO
THE
WOMEN
OF
WEYA

Contents

Introduction to Weya Art 7

Themes of Weya Art 61

Love and marriage 83

Medicines, spirits and witchcraft 109

Social and political problems 139

Conclusion 165

Glossary 178

INTRODUCTION TO WEYA ART

I am a German art teacher. In 1984 I joined the German Volunteer Service and came to Zimbabwe. I have lived here since then. For the first three years I worked at the Cold Comfort Weaving Co-operative on the outskirts of Harare. At the end of 1987 I went to Weya.

Weya is the name of a small communal area in Zimbabwe. I lived there for three years, working with more than 100 women from the surrounding villages. I worked with Agnes Shapeta, the former dressmaking instructor of the Weya Community Training Centre. The women of Weya have become known for their art, be it appliqué, painting, drawing, embroidery or fabric painting.

Judging from the reactions of the many visitors to Weya, I believe there is a genuine interest in the history and the background of the Weya project, the artists and their pictures. Therefore, in this book I want to describe the origin of the project, the conditions of work and the consequences of the art for the women involved.

I present a collection of art works that is representative of the present stage of Weya Art. Each picture is accompanied by a description, written by the artist herself. Additional information on certain topics is also presented in the women's own words. This book is an expression of the traditions and present-day life of the women artists of Weya.

From 1989 to January 1991, I conducted more than 100 interviews with the women. The interviews are authentic, but the names of the women are not included in order protect their confidences.

When I left Weya at the end of January 1991, the artists' understanding of themselves as well as their neighbours' views of them had changed considerably. Many of the artists whose work is included in this book have left Weya. They have tried to make a living in Harare, independent of the Weya Community Training Centre.

This book, I hope, will be a book for everyone who is interested in Zimbabwe, in Zimbabwean art and in the life of the rural women of Zimbabwe.

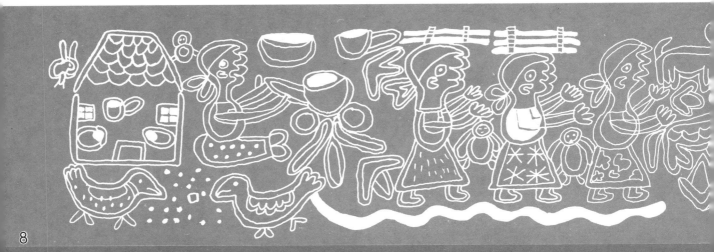

Rural life: the artists' backdrop

Weya is located 170 kilometres east of Harare and is one of the smallest communal areas in the country. The designation 'communal area' is the post-independence name for the former 'tribal trust lands' or 'native reserves'. The name has changed, but the conditions of the people living there have not changed much. Yet, the majority of black Zimbabweans live in the communal areas, where the soils are poor and the rains are unreliable and insufficient. The communal areas are alarmingly overpopulated and overgrazed by skinny cattle and goats. The land is prey to rapid soil erosion because of the people's need for firewood. Old people might remember times when small river beds were filled with water the whole year round; nowadays the rivers might carry water for only three or four months a year. The main income-generating activity in the rural areas is agriculture and it has become much more risky.

No wonder that in most families the husbands and fathers usually try to find some formal employment somewhere in town, often hundreds of kilometres away from home. Their wages are supposed to provide their families with some cash income to purchase the most essential commodities like soap, sugar, salt, tea, cooking oil, clothes, medical treatment, bus fares and to pay the school fees for the children. In not a few cases it happens that these husbands abandon their rural families, leaving them with their subsistence agriculture and sometimes, literally, without a single cent.

These women's descriptions of the life they led before coming to Weya might stand for many others.

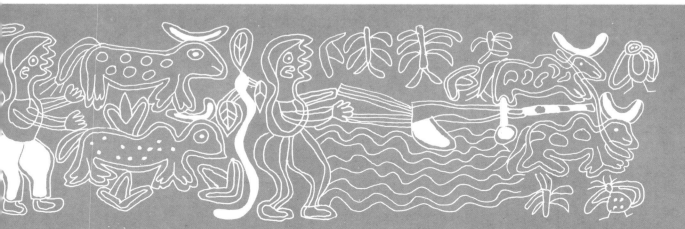

One woman is sweeping and one woman is carrying water.
A woman is moulding clay pots.
Two women are pounding maize.
Two women are carrying firewood.

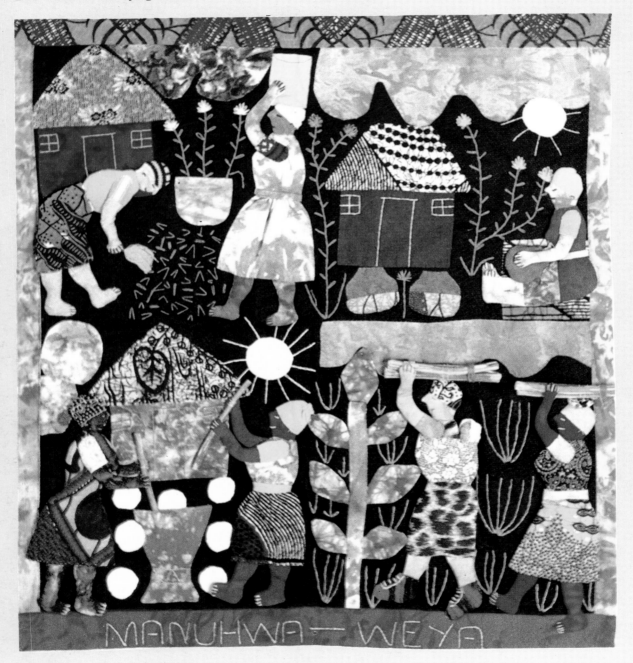

- Work done by women
- Manhuwa
- Appliqué

Flying ants (considered a delicacy when roasted) are picked from anthills. In the late afternoon people dig a small channel following the slope of the anthill. A tin is fitted at the lower end, with its open end facing the upper part of the channel. The channel is completely covered with layers of grass. Overnight the flying ants crawl along the channel and end up in the tin. They can be collected in the morning. People are putting up lamps and the flying ants are attracted by the light. Children are trying to catch the flying ants.

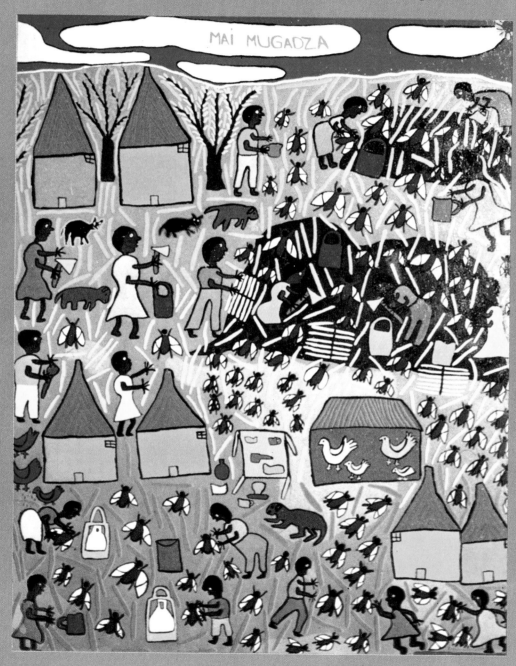

Flying ants ■
Mai Mugadza ■
Painting ■

From 1985 until 1988 my husband, who is working in town, was living with another woman; he was not caring, he was ignoring me and the kids. All the kids stayed with me; he sent no money, only after some months some little money. I thought of leaving my home, but some elder people told me to stay and to wait. My husband was telling me I should not worry, 'It is just a girlfriend and then over'. He doesn't tell me the truth. Since last year he tells me it is over; since last year neighbours have told me that he is living with another woman. The painful thing for me was that he was not even sending me money, and I had five kids and was really struggling.

I grew up without a father: he went to Johannesburg. He left for good. At that time my mother had three children. Then my mother got married to another husband and had four more children. I never heard anything any more from my father. My mother cooks beer for selling to earn money. She takes on all types of jobs in town but not *kufamba famba* (prostitution) to earn money. My mother got married again; I live with my aunt.

I was once married in M. and I have got one kid, a girl; and then the man failed to pay the *lobola* (brideprice) and I was back. That was 1987 when I came back. I was happy. I was grinding peanut butter to take to the farmers and sell for money. I was thinking I could stay with my parents. When someone wants to marry me he has to pay *lobola* first whilst I am here with my parents.

I got pregnant with my son and born him in 1988. My husband was not there; when I born that boy he was in jail. The parents of my husband did not tell me because I was pregnant; they knew that I cannot

born my child in a good way. They told me that my husband was in jail three weeks after I born my son. When I decided to try to see him because he was not writing letters or sending money, I told my brother to telephone him. They replied that he was in jail. He was taken from work because the money was short from the company; he was a manager. My life was very hard.

I used to sew some aprons and skirts and shorts and school uniforms and I sold them. I am a good farmer and I produced quite a number of bags of maize that I keep for buying my farming equipment: a cultivator and ploughs. It has only been four years since I started my own fields, because first you stay with your husband's mother. That time was tough because it is not nice for someone with secondary school education to stay at home idle. If you sew in the village and you do something for $4, you sell it to someone and she can give you 50 cents or a very small chicken. Next month she gives you $1,50 and after five months she can give you the rest, the last 50 cents. You won't buy anything and this means you are working for nothing, no improvement.

It is hard to wait for a husband's pay. This means he is serving two houses: the family at home and his family at work—that can never balance. One month you can get enough things, but the second one you can't. I used to send a letter to him and list the items I wanted; sometimes he came to bring half of it or the next month he brought three quarters of it. I am not blaming him because of his pay and the family he pays for; I blame myself because I was doing nothing. I don't blame my husband because he had a new family and he was paying *lobola* at the same time.

- Brewing beer
- Mai Tawanda
- Embroidery

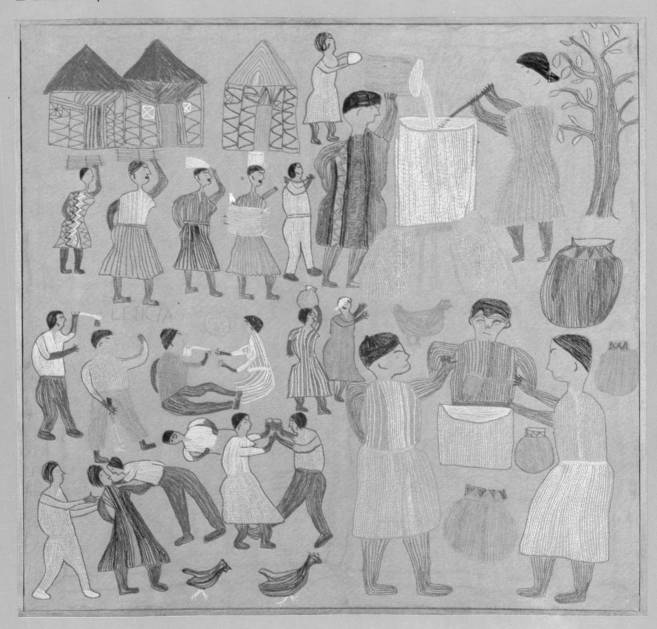

Two women are carrying firewood.
One is carrying a sack of mealie-meal and the other one a bucket of water.
Some are brewing beer.
One man is urinating and one is trying to cut him with an axe.
The woman is taking beer to drink from a small drum.

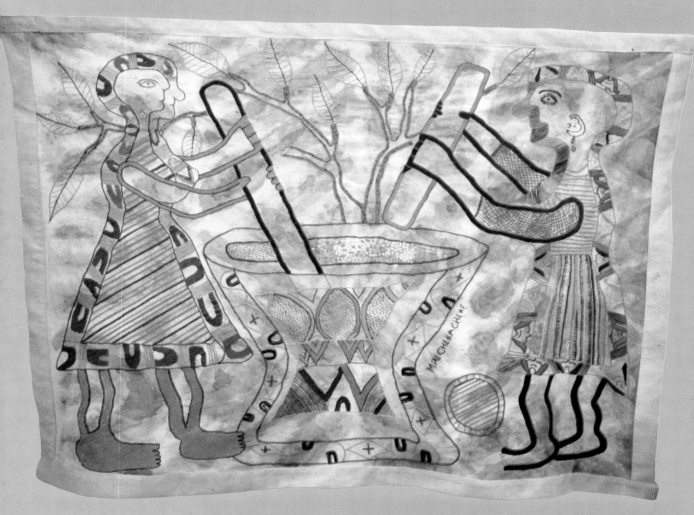

- Women pounding maize
- Mai Chekacheke
- Embroidery

Weya Community Training Centre

In 1975 Mukute Farm Society, a collective co-operative, was started in the centre of Weya Communal Area. Amon Shonge, the chairman of Mukute Farm Co-operative, conceived the idea of the Weya Community Training Centre in 1982. The aim of the training centre was to provide course participants with skills that would enable them to earn money to supplement their incomes from subsistence farming.

The centre offered standard courses: building, carpentry, metalworking and, for women, dressmaking. It would be an exaggeration to say that the courses for men were fully successful: the income generated by the graduates was and still is rather marginal. At least the courses and their products were good enough to start production groups. Prospects for the dressmaking courses were not so good.

Private dressmaking in Zimbabwe is hindered by the existence of a well-established clothing industry. Individual dressmakers cannot compete with the market prices offered by the commercial companies. The material alone, when bought at ordinary retail prices, might cost more than a finished dress offered in a shop. Despite this fact and probably due to the lack of alternatives, dressmaking is the standard training course offered for women: they hope it will provide them with the necessary skills for earning their own income.

The sad reality is that women will walk from compound to compound, carrying their finished products in a plastic bag, begging others to buy them. And usually they will have to leave without selling their wares. In town the competition is too strong, and in the rural areas no one has money to buy more than the essential set of clothing. The same basic situation exists with production of school uniforms: the industrial monopoly, competition in town and non-existent markets in rural areas.

And finally, the high price of most simple hand-sewing machines is an obstacle for an income-generating dressmaking enterprise. Not surprisingly, the Weya dressmaking courses never resulted in women earning money with the skills they had learned.

Early in 1987 the training centre replaced the unsuccessful machine sewing courses with a course in handsewing. Hand-sewing skills would enable women to mend and sew garments for their own families and save costs; in effect, they abandoned the idea of generating income from sewing activities.

The comments of women in the sewing courses show the financial constraints women face.

Another problem everywhere in Zimbabwe, but especially in the rural areas, is the lack of transport.

Three people are waiting for the bus. Unfortunately the bus had a breakdown, and so they have to go back home to Mungure, 13 kilometres away. Also it is raining. A man was waiting for the bus with his pregnant wife to take her to the clinic. Now he borrowed a wheelbarrow to take her to the clinic that is 15 kilometres away. Unfortunately she gave birth on the way. Because of the breakdown people are going back home; some others are crowded 20 in a Mazda.

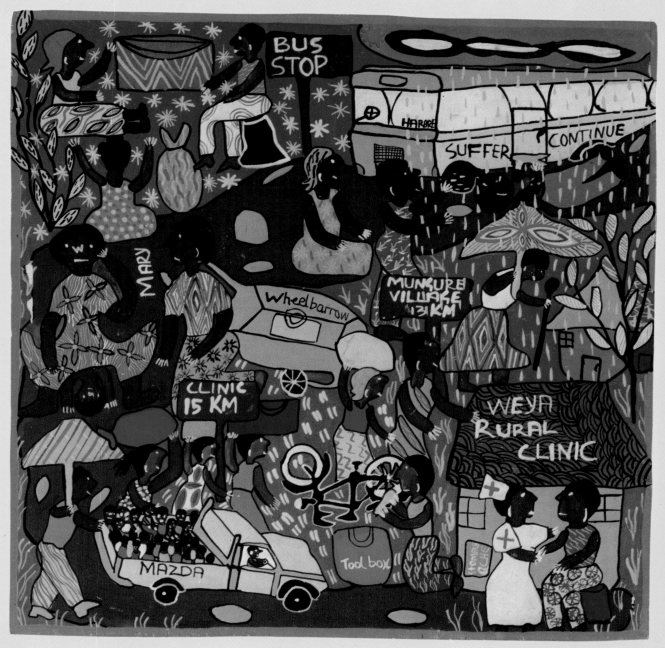

■ Problems of transport
■ Mary
■ Painting

I wanted to start the dressmaking course in 1985, but I was having a baby and my mother was not there. The dressmaking courses started in 1982. When I came in 1983, I was pregnant and could not walk to the training centre. In 1984 I was not staying with my mother, and I needed someone to stay with the little kid. In 1985 the centre was asking a fee of between $6 and $12 per month for buying material and scissors. I did not have even this much money. In 1987 I started the hand-sewing course. There were no fees and the material was not too much. With knitting and selling I managed to have the money for the course.

I never came to the sewing courses because my husband wouldn't give me the money for the course fees—not even for the hand-sewing course. When there were no course fees the material had to be bought by myself. I would have terribly much liked to come.

At the training centre there were only those dressmaking courses, but there one had to pay course fees. I couldn't ask my parents for cash to pay it.

Appliqué

I came to Weya at the end of 1987. Several women who knew me from earlier visits approached me asking for a course that would not only save costs but that would earn money. I would liked to have developed a type of art or craft based on traditional crafts, such as pottery or basketry, produced by the women of Weya. Unfortunately these skills have been lost.

The only crafts actively practised by the women were knitting or crocheting. Although the stitches are often very complicated, the whole product looks so little 'African' that it will never sell in a western market. The local market for craft products is limited and doesn't pay well.

By chance I had come across a publication on traditional appliqués from Dahomey/Benin. The hand-sewing skills of the Weya women were the ideal technical basis for production of appliqué wall hangings.

My idea for the first appliqué story came when I was planning to visit a friend in Germany who had given birth to a baby boy she had named Benjamin. One of the Zimbabwean women participating in the hand sewing course was Mai Benji, which means Mother of Benji/Benjamin. In Zimbabwe women who are mothers are called by their title of respect, 'Mai'; it is polite to address a married women by the name of one of her children. For instance, Leticia is called Mai Tawanda after she gave birth to her first child, Tawanda.

My idea was to have a wall hanging made as a present for my friend in Germany. The hanging would show the life of the boy Benjamin, as if he were a Zimbabwean child. The wall hanging was composed of individual squares, each one of them telling a part of the story. In this way a group of women could work together on one wall hanging. The group work required some co-ordination: the whole story had to be divided into sections, otherwise favourite scenes would appear several times whilst the whole of the story was lost.

Not all the women were convinced that this was the course they had asked for.

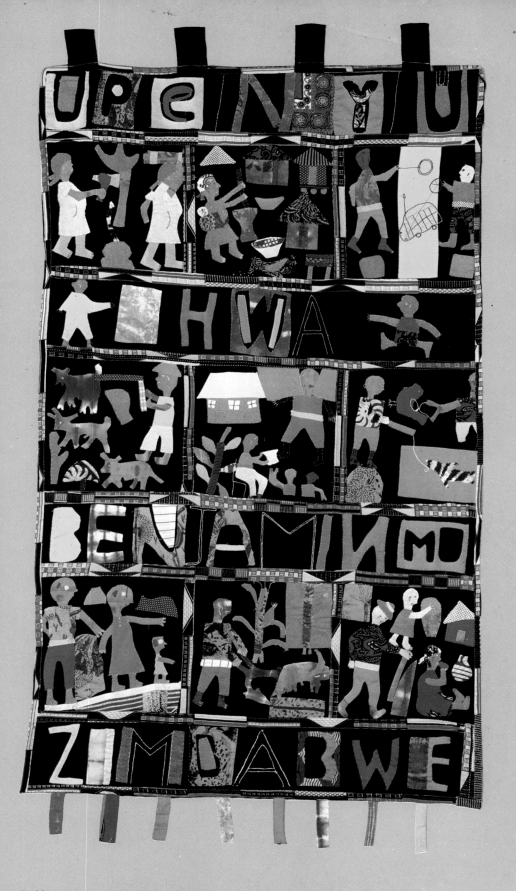

■ Upenyu hwa Benji mu Zimbabwe
■ The first appliqué group
■ Appliqué

I can say I was the only one who was happy when you showed us the appliqué. No one else could imagine what it was; they wanted to do dressmaking. We were 14. The others dropped out and stayed at home; they wanted to come back after the whole thing was over. Only five of us were not complaining; but the others did not even listen to Agnes. We were together, but you could see that people were working maybe only one piece in a whole week. The ones who did not like appliqué didn't know if we could earn money with it. We thought we were playing or wasting time because we had never heard about appliqué. Some women had never been in clubs and had never done anything together or sold anything: they thought it was better to leave. I knew that it was a new thing and it could sell.

First we were all bored doing appliqué: such tiny small things and drawing, we were used to big things. I was in the hand-sewing course; I wanted to make dresses, not appliqué. I thought appliqué isn't going to stay for long. Today, I like appliqué because it earns money and it helps for my living.

When doing the first piece I thought I could not do it. Everything was different, the name appliqué and then just everything that was done: the shaping of people, the arrangement of things. When the test piece was finished, it was joined and sold and then the second one was done. Now it was easy.

And the women in the villages:

We were just laughing, we were saying they walk too much, they are going to the training centre for nothing. We didn't think that people can get money. We didn't put them in our mind that they are doing something for money. I was laughing at those pictures on the appliqué; I didn't think there would be anyone buying those pictures. I changed my mind because of my young sister. She was living at Chakwenya with my mother and she came here for that appliqué course. That was when I began to believe you can earn money through appliqué.

The women are carrying water.
They are going to the grinding mill.
They go to fetch firewood.

■ Village life
■ Chendambuya
■ Appliqué

After the first pieces of appliqué had been sold, resentment changed into enthusiasm. The women were completely inexperienced in visual expression and obviously not much influenced by illustrations in books or magazines. They had kept much of their natural confidence in their own artistic ability although they would never call it so, because it is the men who are supposed to be the real artists. The first appliqué was a challenge because it required them to depict persons and animals. Mai Benji was worried because she wanted to illustrate a goat and didn't know how she could distinguish a goat from a cow. I told her to go out of the workshop and have a look at the real goats. After a short time Mai Benji came back with the answer none of us had known before: it is the short upright tail of the goat that visually distinguishes it from a cow.

Early in 1988 the Weya appliqué women were invited to show their work for the first time at the National Art Gallery in Harare. The next day an article in *The Herald* (Harare's major daily newspaper) appeared, showing the display and the women in front of their works. The Committee of the Weya Community Training Centre started to take the women's department seriously and celebrated the unexpected success by granting a bonus to Agnes. The appliqué women who had gone to the National Gallery never tired of describing the event to those who had stayed at home.

After the first doubts about the new product vanished, the women's creativity blew convention out the window. The women discovered the possibility of integrating 'foreign' materials, such as wood, wire, seeds, plastic etc., into their appliqués or stuffing different sections of the work to make them three dimensional. The only limitation was the weight of the materials used.

Conventional taboos that restricted women from talking about certain things in public or when men were around were not valid any more for appliqué. Normally, in the presence of men, women wouldn't say they needed to go to a toilet. Now, as they understood it, the new media allowed them to show even the private parts of men and women in detail, if there was a story to justify it. Women's secrets, like medicines for love, laughing about drunken men in beerhalls who lose all pride and urinate in public, having sex with a prostitute in public etc., everything was possible to illustrate.

During the following years each group developed its own favourite style of appliqué: the Mungure group enjoys burlesque and heavily stuffed and crowded pieces; the Chendambuya group likes to experiment with a new type of appliqué inspired by the three-dimensional style of Weya paintings (see 'Jonah swallowed by a fish'); the Chakwenya group specializes in reverse appliqué; and the Kushinga artists try to integrate embroidery with appliqué. The women sign their work with their group name.

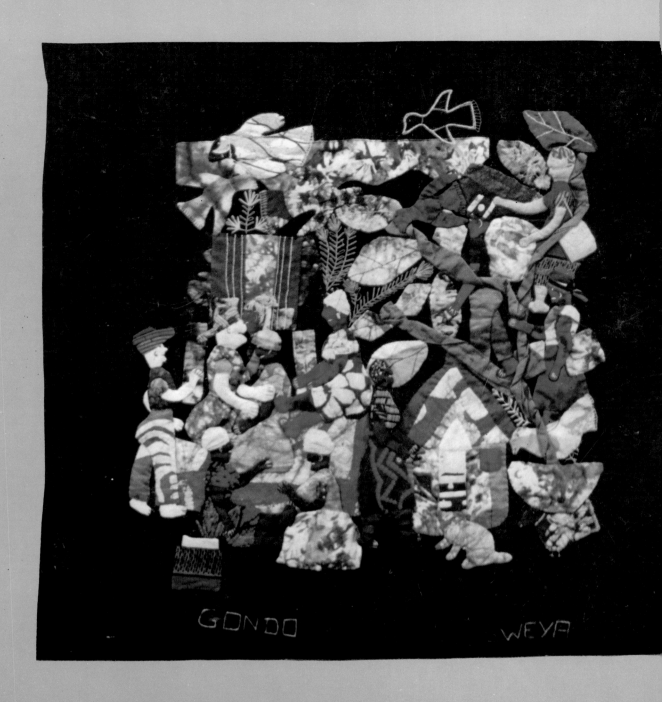

GONDO WEYA

This type of appliqué based on the style of Malangatana has only been produced three times. I had suggested the basic idea of a densely worked picture with a large plain frame as a new prototype. The women disliked it because it required a lot of black material for the frame, which is not covered with appliqué. As the women understand it, this material is wasted. We calculated the price together, including the material costs, but the women were not convinced. After the first three prototypes of this model of appliqué were made, the women plainly refused to produce any of it again.

Painting

By June 1988, the 60 women working in the 13 appliqué groups were producing enough wall hangings to meet market capacity. I therefore had the idea of offering a new course in painting. The pictures would be painted on plywood with water-based paint and varnished afterwards. We only had primary colours and black and white paints with which the women experimented and discovered for themselves a remarkable range of colours.

I wanted to invite the women of Chendambuya to participate. Chendambuya is the name of the nearest growth point in the Weya area, 17 kilometres from the training centre. I had been asked by women of this area to work with them, and, besides, I was not sure there would be enough women left within walking distance of the training centre who would be interested in a new course.

In the meeting I wanted to show the women what painting was about, and I wanted to conduct a little practical test for those interested. I asked Agnes, the dressmaking instructor, to write the invitation poster in Shona that we were going to display at the clinic. Here it would reach more or less all women from the area in a short time. Agnes didn't like the idea. By inviting women only, she argued, we were discriminating against men who needed jobs as urgently as women. Finally we invited both women and men to our meeting.

As a practical test I gave each of the six young men and seven women who came a piece of cardboard, a brush and some poster paint and asked them to paint a neat and clear outline of any animal, even something as simple as a snake. The boys painted wild buffalos and lions and leopards hiding behind bushes, preparing to attack. The paintings were distorted through the boys' efforts to produce a view from a central perspective amidst a wild landscape of trees and mountains in the background (bushes, trees and mountains and the fierce atmosphere were expressed by wild brush strokes).

None of the women had ever painted before. I had to show them how to hold a brush and how to support the hand in order to paint a clear line. The chickens they finally painted were most extraordinary. It was obvious the women had raised, slaughtered, cooked and eaten quite a number of them: they knew a chicken inside and outside and tried to show it. I was excited. I was sure that we would be able to sell the first and all the following pieces of this type of painting. The boys were smiling sympathetically, convinced I was only consoling the women. Full of self-confidence, they considered the clear outline required by my test as beneath their own artistic ability.

The women painted more or less perfect outlines but didn't believe me when I said they had actually passed the test. They had fully accepted the alleged artistic superiority of the young men. The next day none of them came back.

■ Village life
■ Gondo
■ Malangatana appliqué

Long ago people used to live in the forests. They built shelters as houses. Here they are at their shelters. The woman is pounding whilst the husbands are going for hunting.

They are in the forest chasing guinea-fowls on foot. They catch the guinea-fowls when they are tired.

They drive animals to muddy places. The animals won't be able to move faster but it's also a risk to the hunters because they also cannot move faster.

They are shooting animals using bows and arrows, and some animals are resting under a tree without knowing that the enemy is near.

They dig pits for trapping animals and put grass on top to make it level with the ground, so that when the animal comes it will fall in.

They drive the animals into nets. When they are caught by nets the hunter will go and kill them.

They sometimes use *musungo* for trapping animals. The one is caught by a leg and the other is tied around the neck.

They are carrying the killed animal to their shelters.

The mothers kneel down and clap hands when their husbands arrive with meat. This is the way they show happiness and thankfulness to their husbands.

Hunting ■
Abishel ■
Painting ■

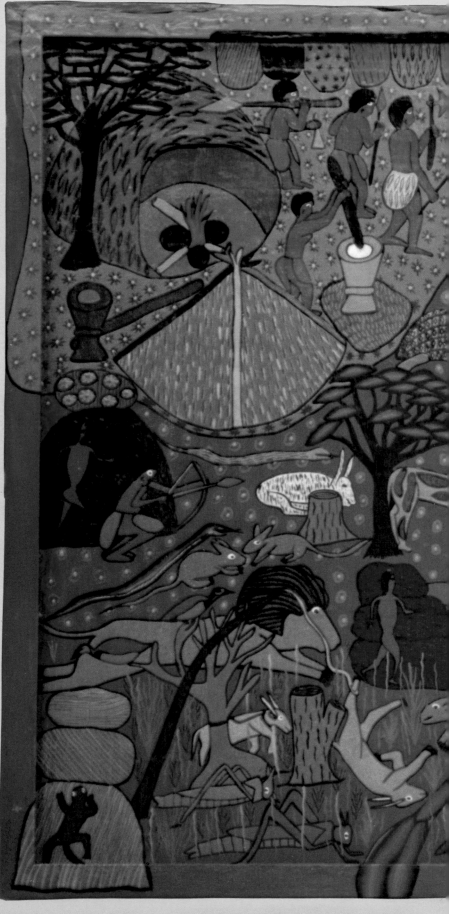

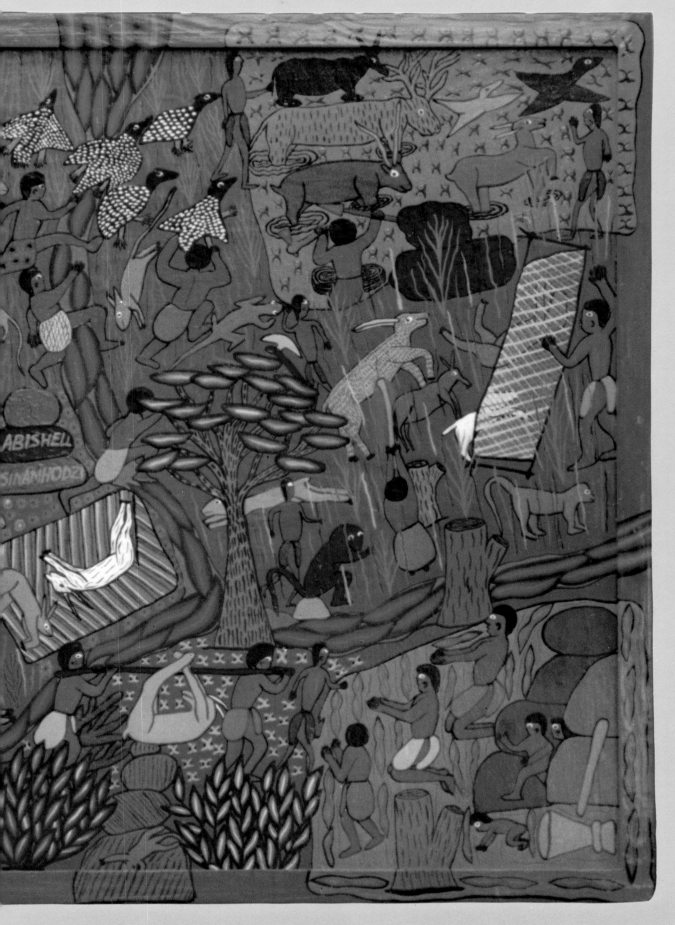

The hunters, Chipezvero, Dambanemhuka and Chaitezvi, are on their way to hunt in the forest. They are carrying their bows and arrows, quivers and axes. Chaitezvi is kneeling on one leg, finding the wind direction by tossing sand in the air, so that they can creep nearer to the animals.Dambanemhuka and Bondanyama, their brave dog, attacked the male kudu. Chipezvero shot an arrow into the neck of the kudu. Dambanemhuka is aiming to strike the head of the animal with an axe. The kudu has lost balance and is falling to the ground.Chipezvero is skinning the kudu. The kudu is laying on its back with its legs in the air, dead. The three men, Chipezvero, Dambanemhuka and Chaitezvi, are camping for the night. They have made a big fire to warm themselves. These men have sited their camp at the foot of the hill where Mangwana-Mangwana, the lion of Chazezesa area, lives. Mangwana-Mangwana has come out of the cave. The jackals have also come nearer their camp, growling fiercely and howling for the kudu they have killed.The three men are afraid of the wild animals, but the lion has already charged and slammed into Dambanemhuka. Chipezvero is up the tree, aiming with his bow and arrow at Mangwana-Mangwana. He shot it on the back and on the chest. The lion jumped off Dambanemhuka and Chaitezvi, 'the brave', axed Mangwana-Mangwana on the back of the head. The lion is lying on its side, breathing for the last time before it dies. Chipezvero, Dambanemhuka and Chaitezvi have shared the meat amongst themselves. They have loaded the meat onto their shoulders and are on their return journey home. The three are crossing a flooded river. They are being led by Chipezvero. Their dog Bondanyama is swimming across the river after a fight against Mangwana-Mangwana, the lion. Chipezvero and the others have arrived home, and their wives are happily greeting them. The wives are carrying baskets to put the meat in. One of the wives is grinding *muporepore* (powder) from *mawuyu* (fruit of the baobab tree) to make *sadza* (thick porridge made with mealie-meal). She is using a grinding stone.

The boys' paintings were technically beyond the naïvety of the women, and I had the difficult task of explaining to them that to make their pictures saleable they would have needed a different and a longer and more expensive training than I could provide. Feeling a bit guilty for the false expectations I had raised with my test, I offered some private lessons for those seriously interested.

Two of the young men accepted this offer. I tried to help them develop their style in such a way that within a short time they would be able to sell their paintings. I suggested a three-dimensional style to force them to simplify shapes and to adjust their artistic ambition to their technical ability and limited knowledge of anatomy and central perspective.

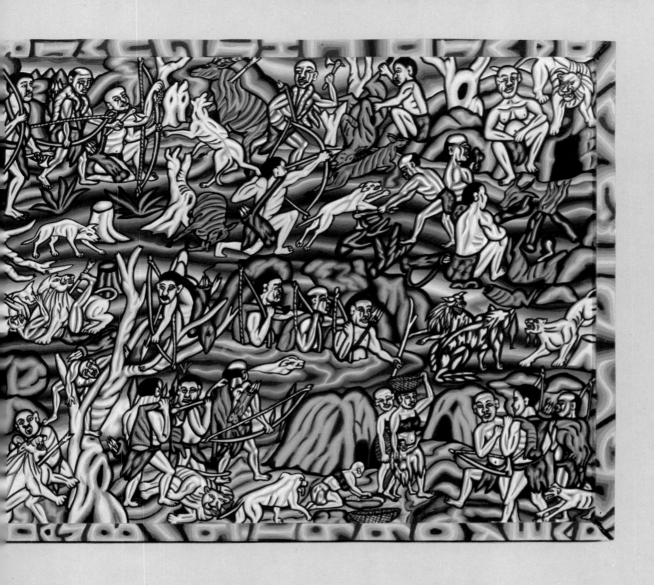

Since then, both Richard Nyemana and David Chigumira have displayed their pictures in exhibitions at the National Art Gallery in Harare. David is earning a living through painting.

After I recovered from the frustration of the first test I tried again. Not daring to invite the women from Chendambuya again, I addressed instead the women from the training centre area. This time, of course, I invited women only. Seventeen women came, 11 passed the test, and later nine more were tested and joined the group. Five of the women were appointed by the others to paint the first pictures. These were priced and displayed in galleries and craft shops in Harare. Within days the paintings had been sold and the other women were asked to join.

Some of the painters remember the beginning of the project:

Painting—I didn't have any idea what it was; it was only when we took the test that I saw what is painting.

At first we were thinking that you are joking, that we are not paid; but now we know. We thought you were joking because we have never heard something like that in our lives. And painting was difficult because we had never done anything like that before—drawing everything, using brushes. I didn't think it could last a long time—that we were doing things like that and that people were buying our things. I was thinking that it will last for only a few days. I aimed to help myself, to try. The day I got the first money—$24—I was very happy; then I realized you were not joking.

I haven't done painting before; I heard about it from those who first came to the interview. I went to the workshop in Magura where they were doing the painting.

Right from the beginning, the women were given the materials as a loan that had to be paid back from a certain percentage of their income. In addition, the women were asked to put a percentage of the sales aside for marketing and administration costs and for the purchase of raw materials. The remaining money was paid out in the manner decided by the women. Over the following months it changed from equal sharing to individual payments. During their three months at the training centre, the women gradually took over the administration, especially the bookkeeping, the buying of raw materials and the marketing of their paintings. After three months, they were asked to find room somewhere in their own villages suitable for workshops.

The women formed three groups that they named after their villages: Magura, Mugadza, Mungure. In the beginning I visited them frequently; later our monthly meetings at the centre were sufficient.

Paintings as well as wall hangings were entered in the 1988 art exhibition of the National Gallery and were honoured as 'Highly commended'.

Over the years the style of the paintings has changed. The first paintings showed their story on a plain background. After some months a new fashion was created by the Magura group. Probably influenced by the appliqué wall hangings, the paintings were divided into partitions, each one depicting part of a story. Later this idea was dropped and the plain background was decorated by dots and lines in different colours.

During this period the painters were overwhelmed by their quick first success, and they started to produce masses of identical looking pictures. The stories were poor, the favourite being a stereotype of village life. The large background was hastily covered with some type of decoration to hide the emptiness of the picture. The finish was poor; often the varnish wasn't dry when the paintings were packed so that they stuck together, spoiling each other. After a short time the complaints from retail shops in Harare reached Weya. The paintings were not selling well; a number of badly painted pictures had to be taken back. This was an important experience.

In the beginning the women found it difficult to produce paintings. The product itself as well as the foreign customers follow criteria of quality that are different from the everyday experience of the rural women. For instance, when a woman buys a product it has to be useful and cheap; usually a product would be considered 'well made' if it served its practical function. No one in the rural areas can afford to pay for the time-consuming labour necessary to produce the fine wood carving on a spoon or the smooth finish on a clay pot that existed in the pre-colonial, pre-cash economy days. The product has its price, decoration doesn't count much.

At first I thought the job was too easy for the money that was charged for the picture. Then, later, I find that the job was just equal to the money. I did not like it right in the beginning. In the beginning I was just after the money, and later I was interested in the painting itself.

Ordinary-type painting is better than Malangatana because you can do it in two days and Malangatana takes five days. Now I am not doing it. Three-dimensional is nice but it is hard to do. I tried already but it is difficult. As a customer I would buy an ordinary type, because in Malangatana you can't see because it is full.

In painting I like Malangatana the most because, for example, at first we were taught to paint the ordinary type and when the times goes and the ordinary type did not have the market, we started the Malangatana. Some who were buying our things were interested in Malangatana and buying another board; so I think Malangatana is better. When you paint the same topic, say village life, the ordinary type and Malangatana, one person can buy both boards.

The works produced by the Weya artists were sold under the brand name of Weya Art. When the first pieces were produced, the women didn't expect anyone to buy them for as much money as we had priced them. When they sold the first pieces, the women naturally applied their everyday experience and understood that the price was linked to the product rather than to the way it was worked.

After this first period of mass production the painters were open to new ideas. I suggested two additional possibilities. First, I showed the women paintings by Valente Malangatana, the famous Mozambican painter. The women were fascinated; they were mainly impressed by the density of the paintings that sometimes left no space for any background at all. Of course they remembered all my complaints about the emptiness of their own paintings. In recognition of the source of their inspiration, the painters called their new style 'Malangatana'.

The second suggestion was the so called three-dimensional painting. This was the style of painting that I had shown to David and Richard. I always had the impression that the women admired the two young men for their paintings and that they had developed a feeling of artistic inferiority. I wanted to show them that they were as able as Richard and David to master the technique.

I think it worthwhile to compare the paintings by Mathilda and David. Both are using the same basic technique, the three-dimensional painting, and technically and artistically both are equal. The result in David's painting (p. 26) is a nervous intensity that is extended, instead of limited, by the frame. Mathilda's painting (p. 82) gains an extraordinarily quiet simplicity that is underlined by the frame. Neither Mathilda's nor David's paintings are expressions of individual artists only, but stand for male and female art in the Weya context. David says, and his painting demonstrates, that he is actually more interested in how to render the fur of an animal and to master perspective in order to attain the illusion of real people than in the story. Since his aim is to paint as naturalistically as possible, his concept of painting is that he can improve, both technically and artistically, with each painting with steadily greater approximation to nature.

When looking at the women's paintings, I have always found it amazing how little importance naturalistic representation has for them. Be it animal or person, once a symbol for something had been developed it became static. Beautifully decorated, the visual symbols are used as letters of the alphabet, which are unchangeable and without a meaning of their own, gaining content and originality by their changing combinations. The ease or difficulty of a painting depends not on artistic or technical skills but on whether the story told is familiar in its details or not.

In April 1989 the National Gallery offered the Weya artists the PG Gallery for their own exhibition.

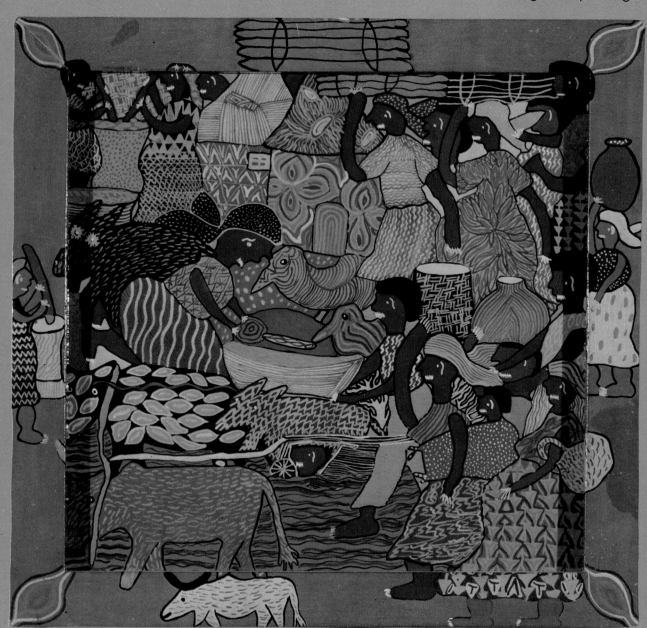

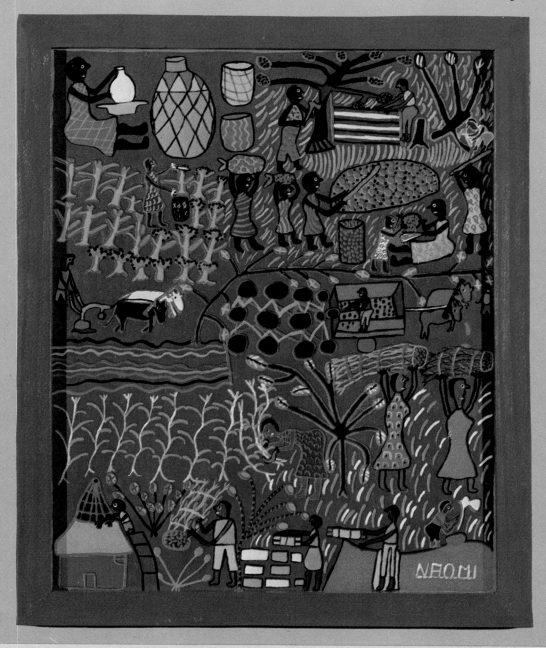

■ Playing drums
■ Mai Charity
■ Painting

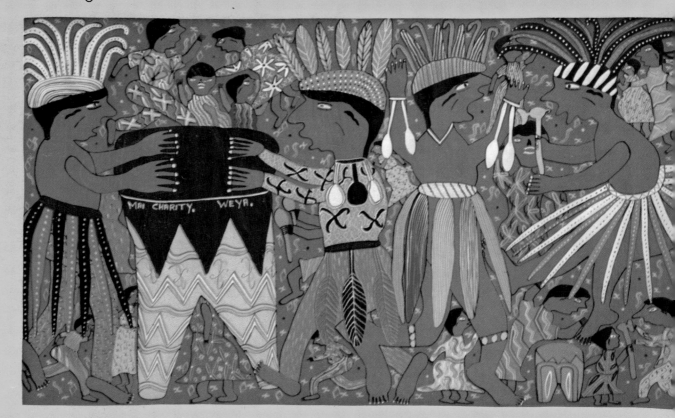

Embroidery

The course that followed in January 1989 was embroidery. Once the appliqué and painting projects were successfully providing their producers with income, the fame of the courses had spread. When I offered a new course in embroidery about 60 women from the area wanted to enrol. Relatives even called back young school-leavers who had been trying to find employment in Harare. Participation in our courses was understood as a guarantee for earning money. Because of these exaggerated expectations, the pressure on Agnes, who conducted the practical assessment, was enormous. As a result, 24 women began producing embroidery before a careful market assessment had been conducted. The result was a bitter disappointment.

The embroidery technique is comparatively labour intensive and hence the costs for a finished product are high. The requirement for a good design was therefore much more demanding than in the case of an appliqué wall hanging or a painting. In embroidery it is critical that the individual producer possess more than average artistic talent. Yet, it seems that the concept of talent is alien to the women (or is it that the financial pressure is so strong they can't consider it?). The women thought the patience of the teacher determines whether the student will be able to master a certain task or not. My European approach in trying to persuade the unsuccessful embroiderers to abandon this particular project and to wait for the next course was viewed as favouritism. It took many long months before a number of thoroughly frustrated women finally gave up.

Their long agony had affected the few successful embroiderers as well. Embroidery became a synonym for failure. Orders received for embroidery were no longer considered by the women, who were now subjectively and unchangeably convinced that embroidery was not selling at all. At present a few women are producing embroidery. The majority of former embroiderers are now producing sadza painting.

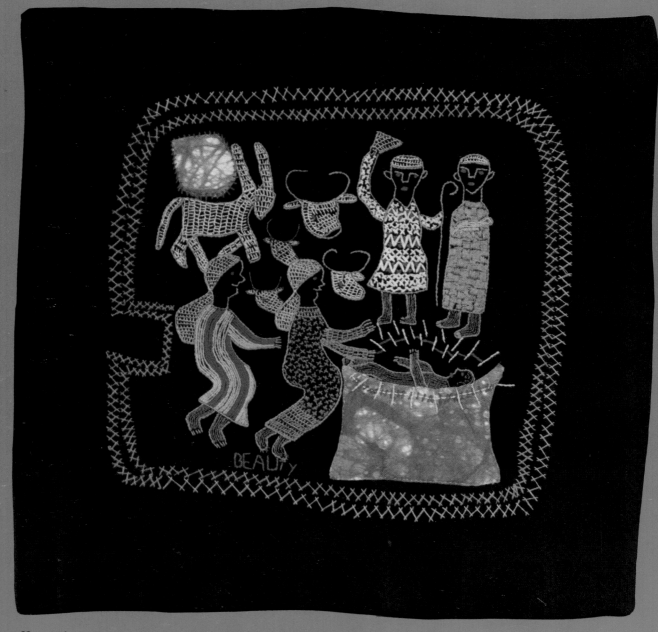

He was born in a manger in Bethlehem. The kings brought gifts to the born baby.

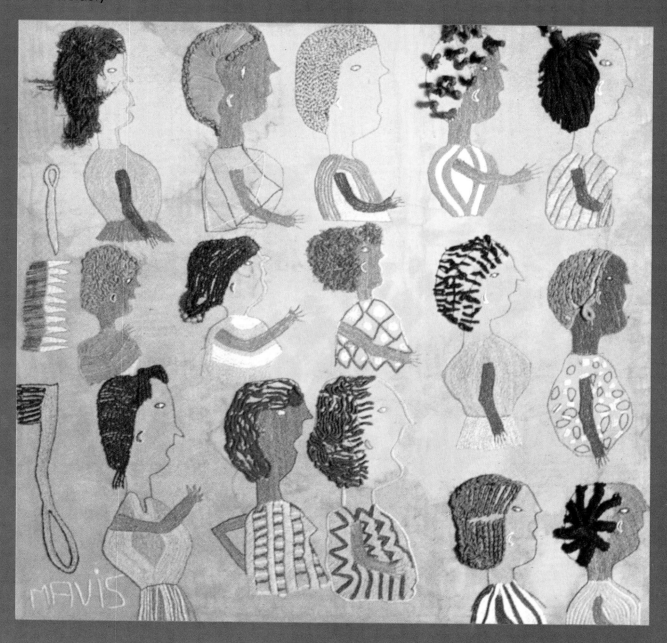

Drawing

After the disaster with embroidery we desperately needed another success. Some years ago, when I first came to Zimbabwe, I had been working on my own colour pencil drawings, using a geographic map of Zimbabwe as background. Based on this idea I offered a drawing project in July 1989. Sixty women took the test, which required the ability to cover a portion of paper with parallel line hatching. The rather difficult test gave precise results concerning the technical ability and accuracy of the participants. Five women succeeded, being rated as 'excellent'. They are the Weya drawers at present.

Originally the women drew with coloured pencils on the Zimbabwe map. The first maps were ready for entering the annual exhibition of the National Gallery in 1989, where they have won awards for three successive years.

Whilst being very successful in Zimbabwe and international art exhibitions, the maps were not finding an easy sales market in Harare, due mainly to the difficulties of display. The maps require a glass frame and the shops were usually not willing to accept the risk of breakage.

The drawers then developed their technique on plywood and varnished the wood afterwards.

Sadza painting

Because of the large number of women who applied for the drawing course, I decided to start another project at the same time, using the results of the drawing test for admission. Five women were appointed by the whole group of selected women to develop prototypes for a new product in sadza painting. The training centre provided the materials for developing the new product. The women were prepared to offer their labour free.

It took two months of experimenting with various textile materials, different types of *sadza*, natural dyes and mordants before we developed the prototype of the Weya Sadza Painting in September 1989. With it we had found the most financially successful product. The sales price acceptable at the craft market was well above the minimum charge per labour hour for a viable product.

Sadza painting is fabric painting using *sadza* instead of the usual wax resist. *Sadza* is the Shona name for the traditional stiff maize porridge, which is the staple food in Zimbabwe.

For sadza painting leftover *sadza* can be used, as well as waste mealie-meal found in grinding mills.

The technique
1. Thin *sadza* porridge is cooked.
2. The drawing is outlined with a thin line of porridge.
3. The outlines are allowed to dry.
4. The picture on the material is coloured with fabric paint.
5. The paint is allowed to dry; it is usually fixed on the material by heating (e.g., ironing).
6. The material is washed. In those areas where the material was protected by porridge, the paint does not come into contact with the cloth. In washing, the porridge washes out and the original colour of the material reappears, whereas all other parts of the material are now coloured.

Due to the severe drought of the last years and the catastrophic maize shortage in the whole southern African region, the women recently changed the technical procedure. Feeling that they can no longer afford to use the mealie-meal for anything else but food, they just paint on the material without using any resist at all. The painting now takes longer because it requires more accuracy, but the result looks very much like the 'real' sadza paintings.

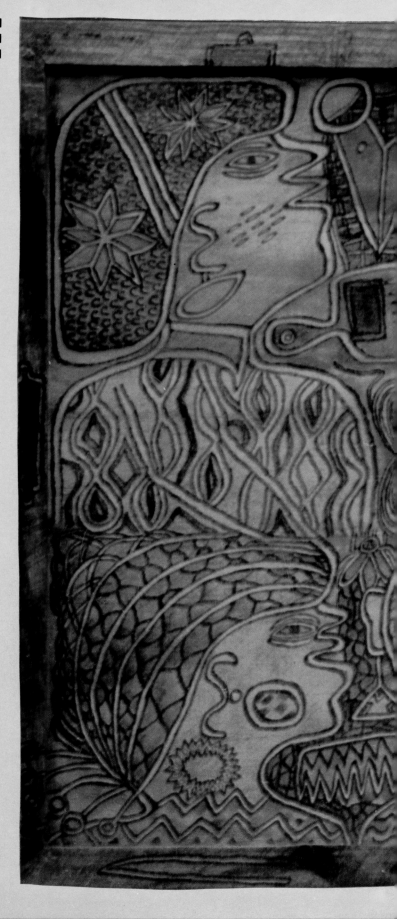

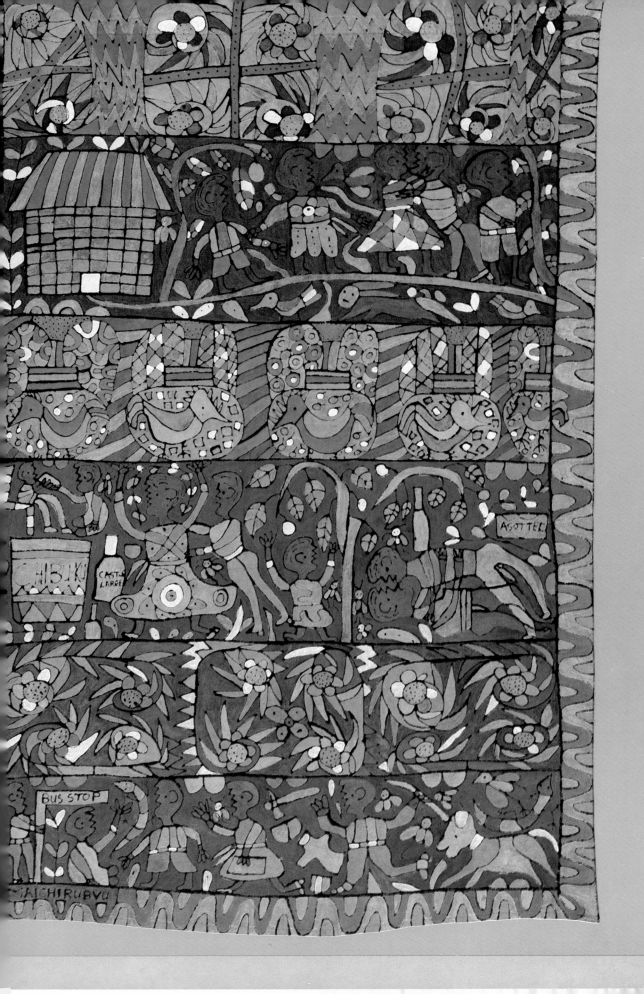

Weya Art in the Weya context

Why does the training centre offer arts and crafts to women? When I am earning money I don't spend it for drinking, I think about the kids, I buy blankets. Some men are not like that. I have seen it several times here, where the men even stay here and plough the whole year, but when the money is coming they go to Macheke and drink and waste the money. So I think we are different, because we cannot enjoy without the kids. The money of women goes to the household; my kitchen is full of cups and pots. It is worth offering courses for women rather than men.

From my money I bought a kitchen unit and some utensils like jugs and pots, plates, blankets, dresses for my children and for me too. I paid builders to put some floor in my house, and I gave my parents some money. The rest I put in the bank account book. I bought a kitchen unit from the Weya Training Centre carpenters, and I ordered a table, four chairs and a wardrobe.

Since we started appliqué, life is far easier for me than before. Even now I can pay primary school fees for the little boys, and I buy materials to sew uniforms for my kids. I can buy shoes. I manage to buy my groceries for the whole month. Before we were cracking our head for the $2 for the grinding mill. Last year I managed to buy fertilizer and seeds and even transport to GMB. I do things on my own. Sometimes when my husband comes home he finds me and I have sugar and everything.

About the money from appliqué I have no complaints; I pay school fees for the children and buy clothes for them because their father doesn't work. He has not worked since 1984. Now I am earning the money in the family. If I was not doing appliqué, the children would not be going to school.

The considerable monthly income of the Weya artists exceeds by far the income of most of their husbands, fathers and brothers. This has created a number of changes concerning the way the artists perceive themselves and also how they are perceived within the Weya community.

The first changes could be noticed in the new garments and the shoes the women and their family members began to wear. Over the years, fashionable hairstyles replaced even the traditional headscarf of many of the married women.

Mukute shop, which used to offer a basic range of goods, gradually developed a comprehensive selection of cosmetics and other items considered sheer luxury in a rural context. A young man opened a hairdressing salon next to the painters' workshop. The carpenters, builders and metalworkers of the area received orders for houses, for door- and window-frames, and for tables, chairs, wardrobes and beds.

My life is nice now, because I am earning my money, and I am using my money without anyone telling me what to do with it. I am planning myself. I have got a banking book and I am saving. I want to use the money for my daughter when she goes to school. I don't want to give my parents hard labour.

I want to help my father so that he can save his money for the boy in the family when he grows up. You know some of the *lobola* is paid by the father, and I want him to have the money to pay *lobola* for the boy and have the money to support his family. You know, nowadays it's hard for a family.

I want to have a passport and when I have it I want go to Botswana and buy things and sell them here—things like radio cassettes and hairclips and clothes and belts. I have already applied for a passport.

I am still planning to go to school. When I was at school I worked hard in all subjects in order to do something in my life, like secretarial work. The problem was the money. I would like to go to the night school because, for the time being, I am an artist during the day. I will paint until four o'clock and then I will go to night school. Now I am interested in art; I want to be an artist.

When I have much money I keep it secret; if you tell that you have money others are telling the witches she has got a lot of money. They do something to you. When I have much money I go to Harare. I buy something I want, I give my grandmother money for the grinding mill and I buy rape. My grandmother does not force me. I like to give her money, $5 or $10, that is enough. I buy clothes for all the family and my brothers at home. Not even my mother knows about the money at the bank. If they know they talk to others. I hide my book. I lock my bedroom so they don't get in. It is my only secret.

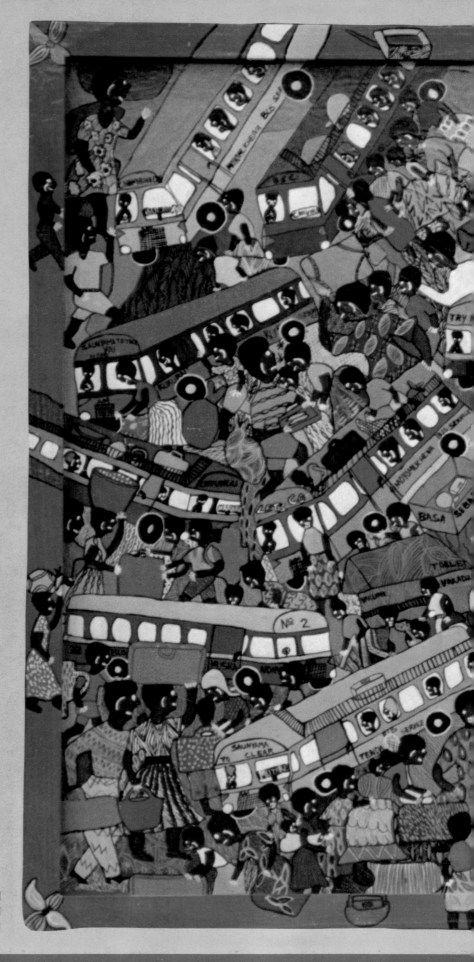

Mbare musika ■
Theresa ■
Painting ■

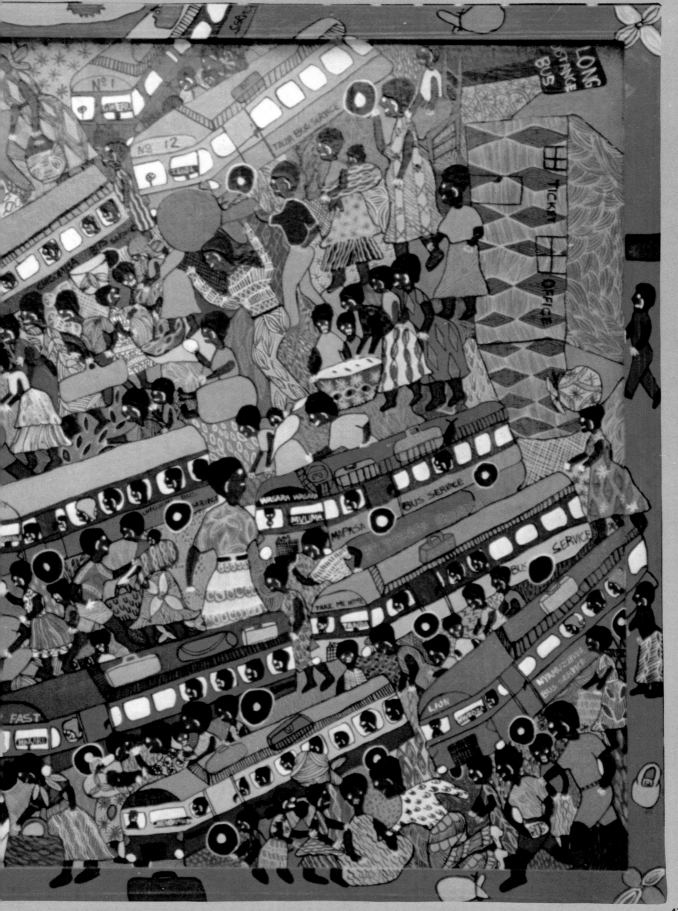

47

Mbare painters

At first this may sound like a story of pure success, but it has another side as well. The Weya artists had gained economic independence and self-confidence through the success of their products and through their contact with the glamorous world in town. Especially the young unmarried women, who worked as a group of painters in a workshop at Mukute Co-operative, were seen by many 'ordinary' villagers as a threat to the existing social hierarchy of the village. At the same time the young women naturally felt attracted by the life in town, a life that promised to be excitingly free of family restrictions and village control.

In May 1990 the two painters' groups working at Mukute Co-operative, which were dominated by the young unmarried women, surprised me by their decision to leave Weya and to work collectively in Harare instead. Only the Magura group, which is formed mainly by married women, wanted to stay in Weya. In individual interviews the painters gave their reasons.

I had been suffering with a headache and diarrhoea, and my parents went to the *n'anga* (traditional healer) and the *n'anga* said I had enemies. I was the first one who had to suffer because the people hate our dressing and even our hair. They tell our parents; they describe me and say do you think that is nice or reasonable. My parents say nothing; they think it is good how I dress. The *n'anga* gave me some medicine and the headache and diarrhoea were over. Right now there are no problems; in the future more problems could be coming. I think I will be sick or my parents will be sick.

If we live here some of the people can kill me because I am earning more money and I am so young. They are my elders and they are jealous. For example, in November I was seriously sick for one week. My mother went to the witchdoctor and he told her that two women are jealous of me because I am earning more money. They say it is better to kill me. The *n'anga* gives me the medicine to protect my body. Last month I felt *kuoma rupandi* (paralysis); my left hand felt weak and it didn't move. It is better to go far away.

Myself I can't walk fast; my leg is broken here at my left knee. I can't sit on the ground, I cannot bend it. It started last week but one. My mother went to the *n'anga*. My broken leg is caused by the villagers. I know by whom, but I can't say. Many people are causing it: they are women only, no men. They are all older than me and they are neighbours. They are saying it is better to leave home, because when I am living here I am going to die. Because I am giving my mother and father money and food, they are not happy. Some are poor and all of them ask me to give them some money. I can't give and then they are not happy. In working here there is no problem; living here is the only problem.

Last week but one my mother was ill and I hired the training centre car to go to the clinic. She is at home now but not feeling well. After that we had to go to the *n'anga*. He said it's your relatives who say that your daughter is at the training centre and earning a lot of money and buying what she wants. My mother says better you go to another place. Here people know the pay-day and even the amount of money one gets.

Another problem is that women say that you are loving their husbands. It happened to me last year. I discussed it with my father and mother and then we solved it. First the woman comes to me at home and we all discussed with the woman, and she said she was told by another person.

People ask me how much I am earning. They say, 'Please give me half of the money because I want to drink beer'. I am forced to give them money because the people are my relatives. It is not my father but brothers and grandfathers. If I don't give them money they can bewitch me during the night, and the following night I will wake up not feeling well. Sometimes I give them $5, sometimes $2. I do not tell them the real money I earn. If I earn $200, I tell them $50 or $60. They believe it. Also women and children ask and I give them money. I think that one-third or one-quarter of my money I give away .

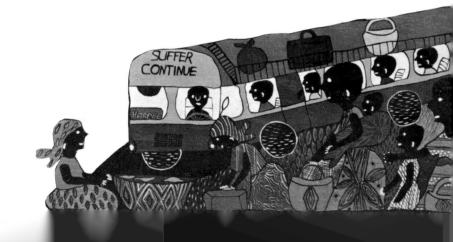

Recently I was buying a tin of beef and everyone was talking about it; everyone was saying I waste my money and don't care. I don't like it. I ate the beef at the workshop. Next day some villagers who were in the shop were talking. I was stopped by a younger lady who accused me of eating meat yesterday. I told her that it is none of her business. The lady said it is not her saying it, but she has heard it from other people. My husband is not happy about it; he is not accusing me, but he is not happy. People will always talk. I will continue painting. People talk because I am getting something.

When we buy something to eat in Mukute, if there are some villagers, they will talk about it time and again. Others say they are not going to find any drink, or even biscuits, because they are bought by the painters. Some say we are loving their husbands. The villagers will post letters and write your name on the back and then say that you wrote the letter.

And the witchcraft—they are jealous because now we are helping our parents, we know that. Whatever we do they want to know it. It started right in the beginning when we were doing painting. But these days it is worse than before. At Mukute we have no problem from Mukuteans. The problems are coming from the villagers.

Other painters who want to stay in Weya describe the situation differently.

Some people only want to work in town rather than in the rural areas. If you are still single, it is possible that you will face the same problems even if you are in Harare. I do not face the same problems. I think the women in the Mungure group are accused because some are after other people's husbands. Some accusations are wrong, others are right. It is not the perming of hairs—once I did it also. If they are making love to some wives' husbands, they have to talk to the wives and stop that and have their own boyfriends. In Magura we are

three single women and we could even break the record in loving other people's husbands, but we are not doing that—that is the difference.

I don't think there are special problems they are facing here. They should cook their food and bring it to the workshop. That they are a group of all not-married women is the reason they go to town. It is a problem for the married women that they think their husbands are proposing to the painters. If the villagers don't understand, the problems will continue. We don't think they can solve the problem by going to Harare. But if they feel like going to Harare, they should go. They will put more time in their work when they are in town because there are no fields to work and they are independent again.

When they work in Harare and use the same name then that will cause problems. I think the ones remaining here should be Weya painters and the others should change their name.

That was how the nickname Mbare Painters was created.

I found myself caught between sympathizing with the young painters who wanted to live in town and worrying for the future of Weya painting and Weya Art in general.

The exodus of the painters would have interfered with the objectives of the project in many aspects. The project had started with the aim of rural development through income-generating activities for women. In the first years young women had actually come from town to Weya, thereby reversing, on a small scale, the hopeless trend of movement from the rural areas to town. Now it became obvious that in the rural context the financial success of the project was a threat to the producers and forced them to leave. Optimistically, one could view the project as a success in that a group of young women had gained enough knowledge, experience and self-confidence to envisage a professional future in town.

On the other hand, I felt responsible for the remaining married women and their products. If the painters in Harare were as successful as they hoped, how could we be sure that they were not training other artists and flooding the market with Weya paintings? Who would guarantee the quality and the standard prices that resulted from the Weya central control and monopoly position? Would the painters in Harare be allowed to call themselves Weya painters? Would Weya gain by forcing them to abandon the brand name if the product was not changed as well? Or could, and should, Weya stop the painters from painting their type of paintings in Harare altogether?

This time the difficult decision was not left to me alone. Instead, and for the first time, an overall identification of Weya art women with Weya Art took place. The management committee of representatives of all product groups called an emergency general meeting of all Weya artists to try to persuade the painters to stay in Weya. The meeting failed. The Weya art women then decided to call in a higher authority, the Committee of the Weya Community Training Centre. This Committee is composed of the respected old men of the community. They decided that one representative of the village elders should speak to the reluctant painters.

The meeting took place. The honourable village elder gave a brilliant rhetorical performance, reminding the young painters of the responsibility they had for the welfare of their home area and for their families, which they were not freely allowed to leave behind. With unquestionable authority the old man imposed on all painters a general prohibition to paint until the decision of going to Harare was abandoned altogether. I felt nervous because we wanted to participate in the big annual art exhibition at the National Gallery and the deadline for entries was too near to lose time. The meeting went on. In a most experienced way the old man singled out those four brave painters who were still not willing to change their decision. He sent the other painters out of the meeting. And now, facing this most powerful old man alone, the young women finally backed down. Generously, the old man lifted the ban on painting, and all agreed that no one was ever going to talk about Mbare painters again.

I was emotionally torn between relief because the project was no longer in jeopardy and pity for the brave young women who had actually not had a chance to live the life they wanted. And I doubted the long-term effectiveness of such a forcibly imposed agreement.

Now two years later all of the painters who wanted to leave Weya have found their own individual solutions: quite a number of them have married in the meantime and live 'legitimately' with their husbands in Harare. Others have left the umbrella of Weya Community Training Centre and are 'side-marketing', that is privately selling their paintings.

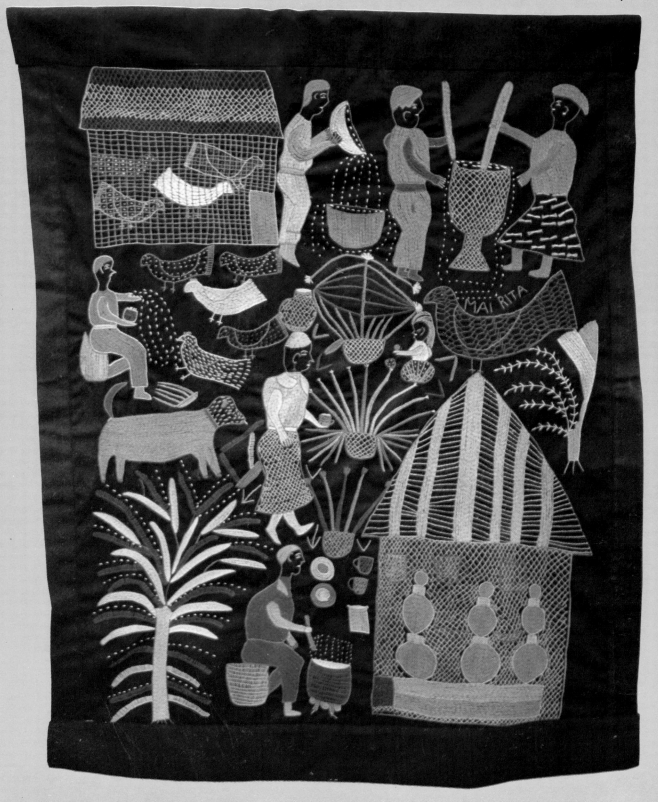

Side-marketing

By the end of 1989 the whole Weya Art programme comprised more than 100 Weya artists. Because of its enormous success, the administrative work had grown to such an extent that the programme needed thorough consolidation. Committees were formed on a group level as well as on a central level. The central committee was responsible for policy decisions and quality control. I tried to develop amongst the artists an identification with Weya Art in general that would give them a stronger position in the market. The small groups had already developed a strong feeling of group identity.

By 1990 it was obvious that a number of Weya artists were selling their products directly to sales outlets in Harare, instead of marketing through the central channels of Weya Art.

Weya Art was organized so that each production group, such as appliqué or painting, had it's own appointed marketing ladies who would go regularly, usually once a month, to Harare to deliver the finished products. Each production group had two secretaries to do the bookkeeping and work out the monthly payments for each member according to the individual monthly sales. Since the outlets in town would normally sell on a commission basis, payments were made only when a piece was actually sold. In order to cover the costs of marketing and administration, 10 percent of the sales was retained by Weya Art. In addition, 20 percent of the sales had to be reserved for the purchase of raw materials.

Meanwhile the craft shops in Harare were offering cash payment to individual women and, at the same time, bargaining to bring the prices down. Lured by the immediate cash on hand, quite a number of women accepted the offer.

Side-marketing threatened Weya Art financially. The women were paying marginal amounts of money into the administration, marketing

and raw material accounts, while still receiving full service for fewer products sold through official channels.

I remember well a meeting of the Weya Art Management Committee, formed by two representatives of each producer's group and myself. I had worked out a whole catalogue of measures to prevent side-marketing. I presented my suggestions. In the following discussion all committee members agreed that the steps would effectively stop the side-marketing and that we should implement them as soon as possible. But at the end of the meeting the women refused to present our decision to the general meeting of all Weya artists. They were scared of witchcraft. Even my offer to present the measures myself was thought to be too risky and, therefore, not accepted. Honestly fearing for their lives and their families' health and lives, the women begged me to forget about my catalogue and never to introduce anything like it again.

As a result, side-marketing became more and more popular amongst the women. In the meantime, Weya Art can be found countrywide in all types of craft and curio shops and public markets. Women can be found selling their paintings in front of hotels and petrol stations. Names of new artists appear, artists who never received official training in Weya and who often have no idea where Weya is. In general the quality of the products is low. Although the sales prices are relatively high, I wonder how much a share the producers actually get. Many Weya artists have left Weya and live in town now where they escape the control of the local community and hope to be near their markets.

Weya Art tried to survive by training other women in the established techniques and products. These women will have a chance only when it is seen that their products are of definitely higher quality than those of the side-marketers.

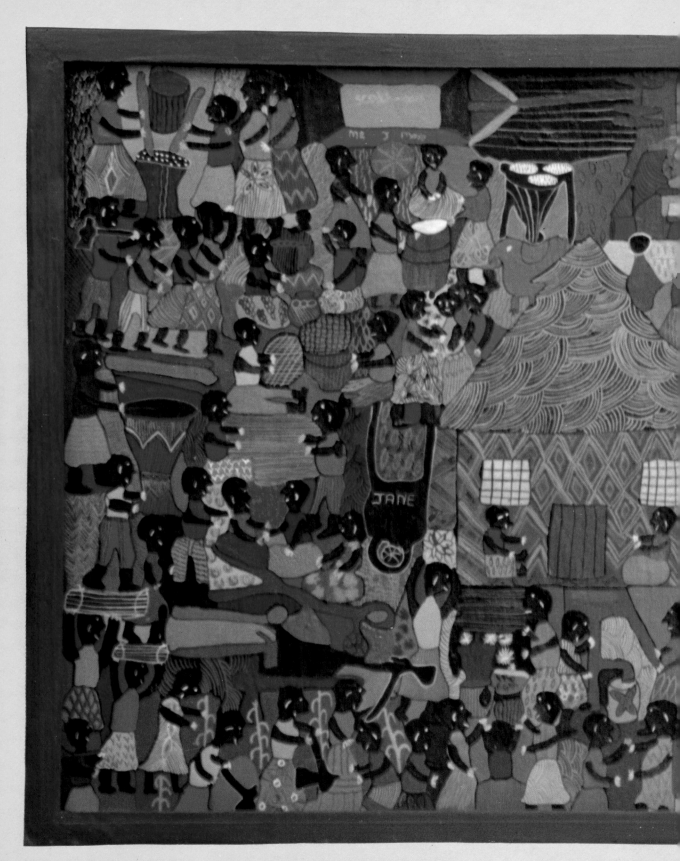

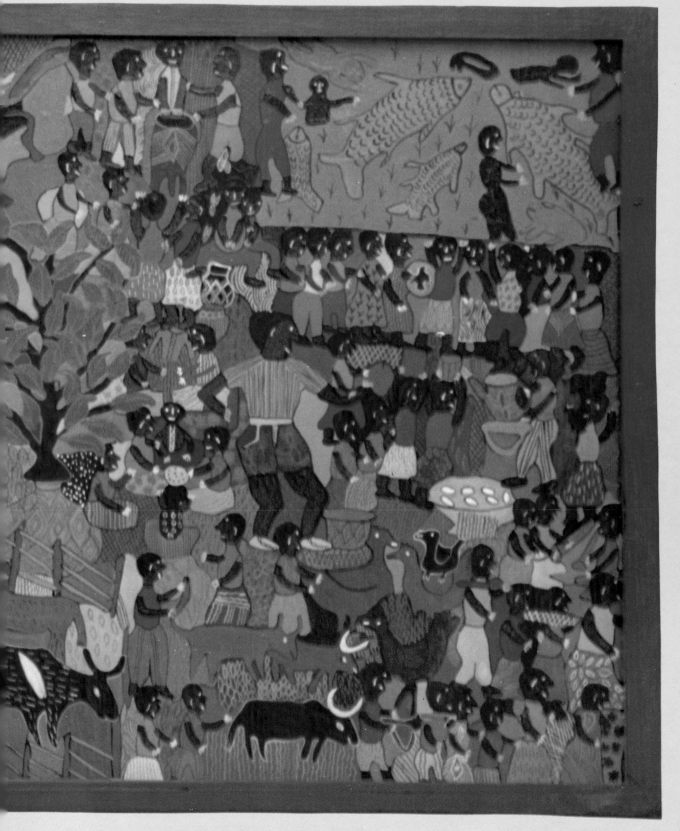

Amon Shonge Gallery

Amon Shonge was a member of Cold Comfort Farm Co-operative. When it was closed down by the government of Prime Minister Ian Smith in 1972, Amon went to his home area, Weya, and started Mukute Co-operative. He was chairman of the co-operative until he died in a road accident in 1986. In 1991 the Cold Comfort Farm Trust opened the Amon Shonge Gallery on its Harare farm. The gallery provides Cold Comfort weavers, as well as Weya artists, with a Harare sales outlet that does not charge the high markups of other craft shops and guarantees the highest possible returns to the producers.

I imagine that a number of Weya artists will want to come under the protecting umbrella of the Amon Shonge Gallery, after the hard but necessary experience they have endured during the last two years.

Weya art or Weya crafts?

A conflict inherent in the concept of Weya Art is the contradiction between the individuality, creativity and uniqueness of art and the standardization, creation of a brand name and mass production of crafts. Weya Art tries to maintain a difficult balance between the two.

The project was thought of primarily as an income-generating activity for women and not as art training. The aim was to create income, as high as possible for as many women as possible. Whereas handicrafts are barely paying 50 cents per labour hour, the art market offers (even for 'mass products') the prospects of earning from $1 up to $5 per labour hour.

In Weya, 70 percent of the women applying for a course qualified under the assumption that every human being possesses creativity by nature and is capable of artistic expression, if it has not been suppressed by incorrect art education.

For marketing reasons we promoted the brand name rather than the individual names of the artists. Weya Art products are standardized by sizes, prices, technique and quality. This facilitates the production of larger numbers, the purchasing of raw materials, the ordering of goods and it avoids quarrelling about prices for each product again and again.

The women contribute to the pricing decisions. But the concept of pricing is alien to them, and it will take time before they fully internalise the idea that the price of a product is influenced by the time spent on its production, as well as the quality that is achieved.

A buyer for a craft shop was complaining about a lady who was selling baskets to her: sometimes she would come with a number of baskets, selling the whole lot very cheap. The next time she would come with one basket only and try to sell it at an astronomically high price. The explanation was this: when the basket lady came to town she usually had a list of items she wanted to buy, be it sugar, oil or soap. The prices of her baskets were solely determined by her immediate need for money for the purchases planned.

Obviously, some women are more artistically talented than others. Tying them into the Weya Art frame means that they are used as an inspirational force for the whole programme. It might also mean that they are not able to develop their own individual talent to the fullest extent. Weya Art has been criticized for promoting the brand name rather than the individual artists; this has also been understood as suppressing female artists because of their gender. I think, however, this illustrates a permanent conflict for Weya Art: that of trying to reconcile art with craft.

A boy and girl are having a picnic in the forest. A man and his wife are coming from the forest to fetch firewood.

The bus is coming to Mukute to take people who are going to Harare.

A woman and her daughter are going to the village for a visit to their relatives.

Two boys are coming from school. Two women are busy gossiping.

A woman is pounding maize.

Three girls are coming from the grinding mill with a Scotch cart.

A man is cutting a tree for firewood. Three girls are playing rope.

A woman is washing clothes.

A woman and her husband are visiting their relatives. Three boys are hunting.

A woman is grinding peanut butter. A man is herding cattle.

A boy is fishing at Mupfure River.

People are dancing to drums whilst others are drinking beer.

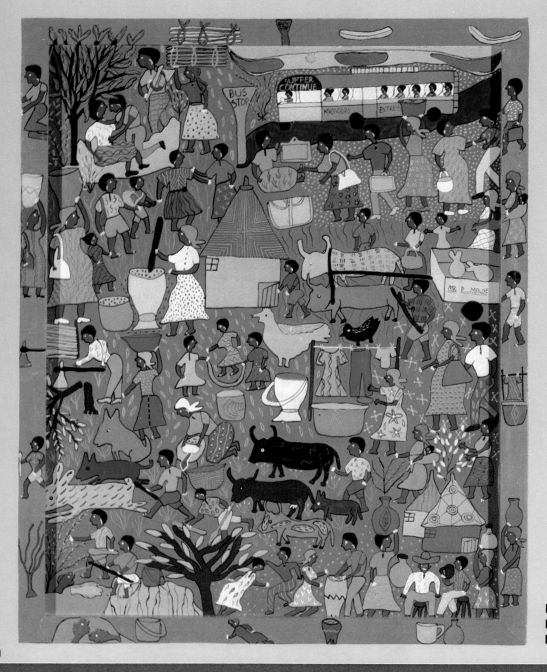

■ Village life
■ Mary
■ Painting

THEMES
OF
WEYA ART

The pictures of the Weya artists represent all aspects of the lives of rural Zimbabwean women. Everyday life in the village is the most common topic, showing the daily duties of women, men and children. Even though the actual work is boring routine, it has become a mass-produced stereotype of Weya Art. The 'village lives' theme is a favourite in the tourist market and with the women artists. The women are familiar with it, and it requires little effort to produce correct details, unlike new traditional topics. The women's understanding of art differs from the Europeans'. If the first product a woman produces is judged as excellent by me and if it sells immediately, then the woman's logical conclusion is to produce in future similar versions of the successful product. My understanding of originality and creative changes and development are alien and against all logic for the Weya artists.

Sometimes customers give new inspiration when they ask for a certain topic to be made. This was the case with 'Going to the beerhall', ordered by a white farmers' club, and with 'Going to the *n'anga*' (the traditional healer), ordered by a German medical doctor. Both requests started a whole series of stories dealing with beerhalls and *n'angas*.

In cases, where the women are not familiar with an ordered topic, they solve the problem by integrating whatever they understand of it into a bigger story. This was the case with *'Kuoma rupandi'*, which means 'The parts are dry' or that someone is paralysed. A Dutch psychologist who had worked on this to pic in another area of the country ordered the picture.

Sometimes the story serves as a vehicle to show what is of real interest to the artist, be it a technical problem such as the representation of water in 'Jonah eaten by a fish'.

In other cases the topics have a direct connection with the life of the artist who first represented it. Take for example the case of *'Mupfuhwira*—Medicine for love'. The theme was introduced by a young woman who was treated so badly by her husband during her marriage that she finally left him. *Mupfuhwira* is medicine that would have turned him into a loving husband.

Most of the Weya artists have developed their own favourite topic.

I like stories. Sometimes the story will be really interesting. Traditional life, No! I don't want the culture. I don't really know what was so long back. I never heard any of the people who come to buy my pictures say I must do a picture about the culture. I want to show them things they are not allowed to do, like talk in the secret forest when seeing strange things happening on the mountain.

Village life

I have plenty of topics that I like. My favourite topic in painting is 'Work that women do', because I know the jobs we are doing because I am a woman.

Painting is a means of earning much money, but it is also showing others how we live. It is important, sure. Because in 20 years life will be changed and our children can see through our pictures how we were living. We do many 'Village lives' because they are on big demand, on bigger demand than the others.

My favourite topic is 'Village life,' because that is what we do every day. Most of our things are traditional, and the people who buy don't have these things in their countries. When we have money we could buy such things from Germany, about German life.

The topic I like most is 'Enjoying life', with drums being played and people enjoying a picnic and drinking beer; playing drums is nice; I want my body to be fit.

Boxing is my favourite topic. I have seen boxing in Harare. I usually see it on the television at my aunt's place. The fights make people happy, it gives pleasure to the watchers. I have only seen boxing, not soccer. I saw boxing in 1989 in November, and this is the first time I have done boxing in embroidery.

A day in Shona life ■
Mai Stanley ■
Sadza painting ■

One woman is cooking and two are carrying fire-wood, and the other one is herding cattle. A man is herding cattle and now he is fencing his fields. Two girls are playing *nhodo* (jacks), some others are playing fishfish and two are playing netball.

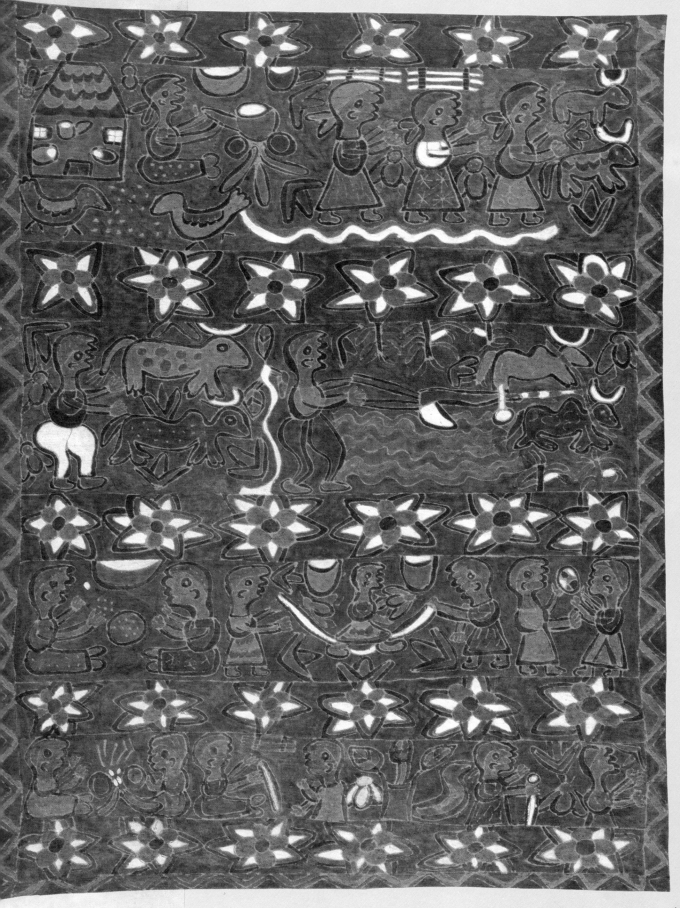

Three boys are hunting.
Two women are carrying firewood.
A woman is washing plates.
A woman is pounding.
A woman is carrying water.
A boy is herding cattle.

Rural life scene ■
Tambudzai ■
Painting ■

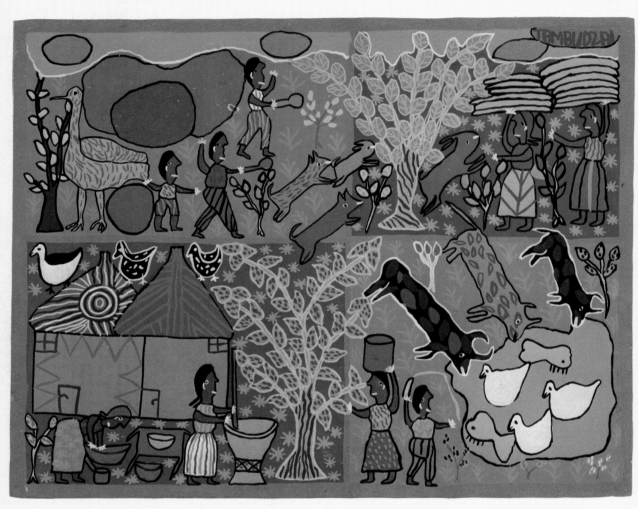

People are drinking beer.
Now they are dancing.
They are in love. Old men are in love with little girls because the old men are drunk.
They are urinating outside the toilet.
Now the men are fighting for a girlfriend.
They are going home and some are falling down.

Drinking beer ■
Enesia ■
Painting ■

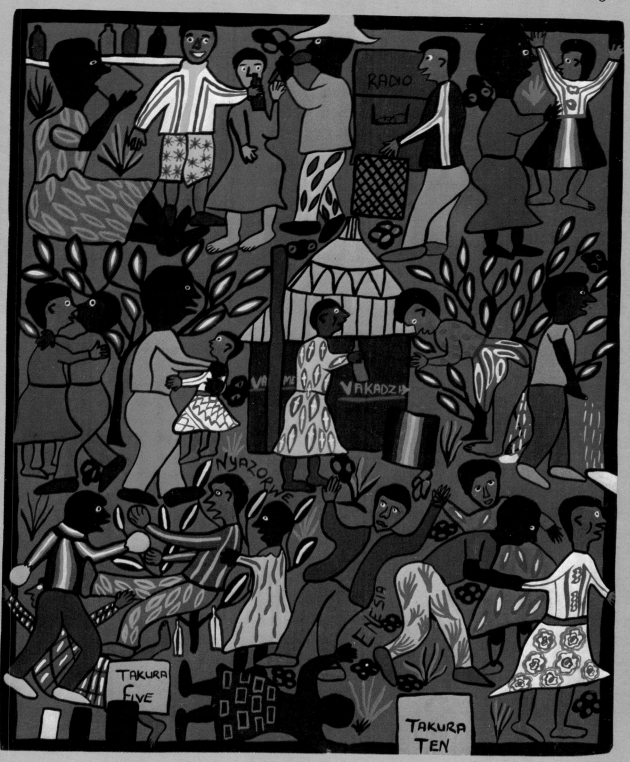

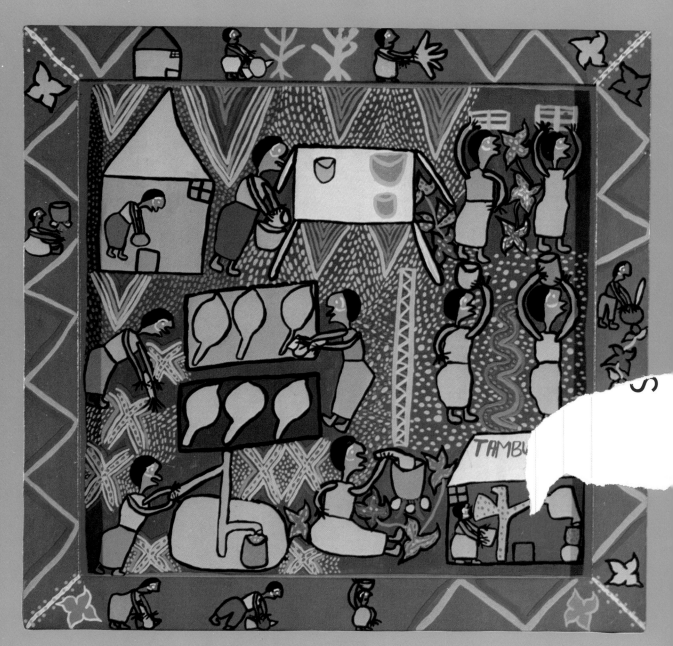

- Rural life scene
- Tambudzai
- Painting

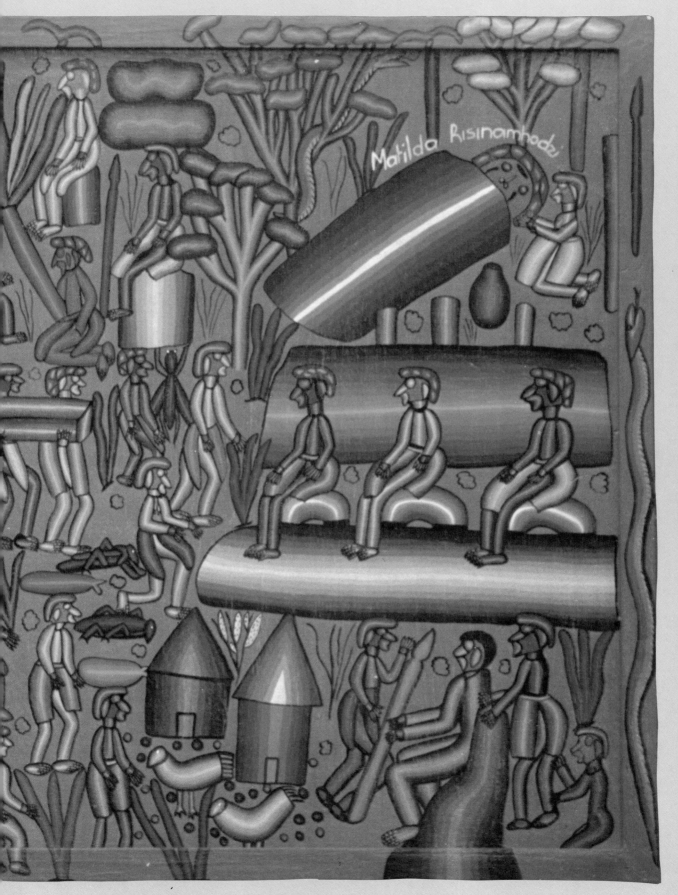

I don't like traditional life; I don't know tradition. The others know better because they are told by their grandmothers and grandfathers. I didn't ask. Today it's nice —in traditional life they were wearing feathers and nowadays we are wearing dresses; and in traditional life they were in caves and now we are in houses.

These days I can share a joke with a man; before now it was rare. I am wearing this dress, my knees are free, which is not allowed. My mother told me during her time a man is not even allowed to see your calf. I think it is because of the change of times and the mixture of people. We are copying Europeans, we are losing our tradition because of copying. We want to do something about it, but I doubt we can. Take that picture of boys hunting— nowadays you don't hear boys talking about going hunting. Where would they hunt? These farms and the forests are clear, no ways to hunt these days.

I like the third stage of 'How chiefs were buried' where the relatives made private the illness of the chief and his death and the drying and the burial. And they made the people notice that the chief is no longer living by the smoke that is produced by the grain leaves and drum beats. I think they made it clear to everyone that the chief is dead after the burial. If they know before the burial, people will start quarrelling about the seat, about the new king to be selected and the burial of the dead chief will be not made in peace. Since he is a big person he must be buried in peace and everything must be done in peace. It is an important story because it makes us know of the past and how our ancestors lived.

■ Traditional and modern behaviour
■ Naomi
■ Painting

Grandfathers are telling the boys how to behave. But these days boys and girls always go to the picnic.

A girl is giving her mother a dish without respect. A girl is giving her mother a dish with respect.

But long ago girls helped their grandmothers. Now Chipo is helping her grandmother by carrying firewood. These days we are not helping our grandfathers. Now Rudo leaves her grandmother carrying their firewood.

The aunt is looking for a girl while she is still a virgin. A girl is still a virgin when she goes with an egg to her mother and the egg does not have a hole. If it has a hole, it means she is not a virgin. Rose is not a virgin because she is sleeping with a boy.

■ Chipwa — beer brewed for rain
■ Mai Desderio
■ Embroidery

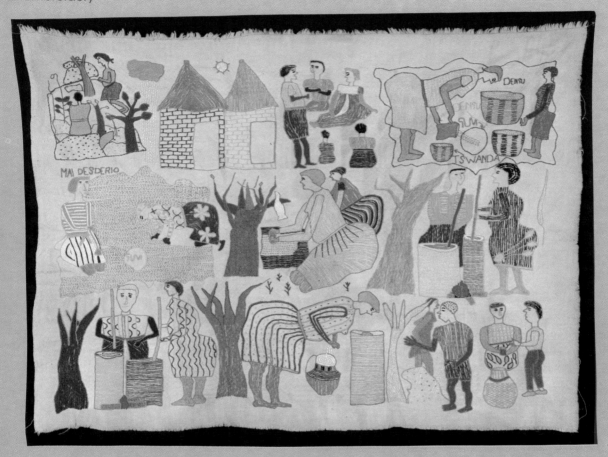

Chipwa is a ceremony for asking for rains.

In this first picture the old people are under a *muhacha* tree asking for some rain to come. They bring some rapoko under the tree. After they have spoken to the spirits they go home and they discuss with the elders what to do. The women are packing the rapoko in some containers; they are on the top of the rock where there is a hole for the rapoko to germinate in. They will pour some water in the *guvi* (hole). The containers with rapoko must not be touched by young people but only by the old generation. You can see that these are old people only. We believe that old people do not sleep with their husbands any more; so they restrict it to old people. After the rapoko germinates, they spread it on a rock to dry and then it is ground by old people again. Now they are grinding under a *muhacha* tree. After that they take the ground rapoko and they start brewing. Once the *hwahwa*, the beer, is brewed, they pack it in clay pots—it is all done by old women. The men have been drinking and they are busy urinating behind a tree or a rock. That is the end of the story of what is done in the forest under a *muhacha* tree. They dance and drink quite a lot and get drunk and sing some embarrassing types of songs. Sometimes they will sing something about men's private parts or women's private parts. Afterwards it will rain; sometimes it will rain heavily. Most of the time it doesn't. It is any *muhacha* tree as long as it is a big *muhacha* tree and not the same tree they held it under last time.

Ngano — folk tales

I have a new topic, a *ngano*: 'A baby and a hare'. A family is going weeding in the field, and they don't have another child to look after the baby. They meet the hare in the field, and the hare says to give him the baby to look after. The hare takes the baby to the forest. When the family wants to go, they want to take the baby but they can't find it. They go home alone. They go to a *n'anga* and the *n'anga* says the hare likes drums too much. They cook beer and then they start drinking beer and playing drums. The hare comes with the baby and they take the baby away. My grandmother tells that story. At home they tell me more stories. Only my grandmother tells me stories, not my mother.

A man who has three wives ■
Mai Sam ■
Sadza painting ■

Long ago there was a man who had three wives. One day the man decided to go hunting with his dog. He struggled the whole day but only caught a tortoise. Hungry and tired he went home. When he arrived, he first asked the third wife to cook the tortoise for him, but she refused. Then he went to the second wiᶜe and got the same answer. At last the first wife agreed to do the cooking. She did the cooking so nicely that the third wife's mouth watered. After the cooking the first wife went to fetch water and left the cooked meat beside the fire to simmer. The third wife ran into the first wife's hut and ate all the meat, leaving bones in the pot, and went out. *Sadza* time came, and when the first wife opened the pot she was greeted by bones and a pot of soup. She was totally surprised by what she was seeing. The husband gathered all three families and asked whether anyone had eaten the meat. The only answer he got was, no I didn't. The man took his family to a witchdoctor (*n'anga*) to find the one who ate the tortoise. The man took the family dogs to the river. He put a thin rope across the river, where the river was deep. He asked the family to cross the river using the rope; he told all three wives that the person who ate the tortoise will fall into the river and die. The third wife fell into the river and died.

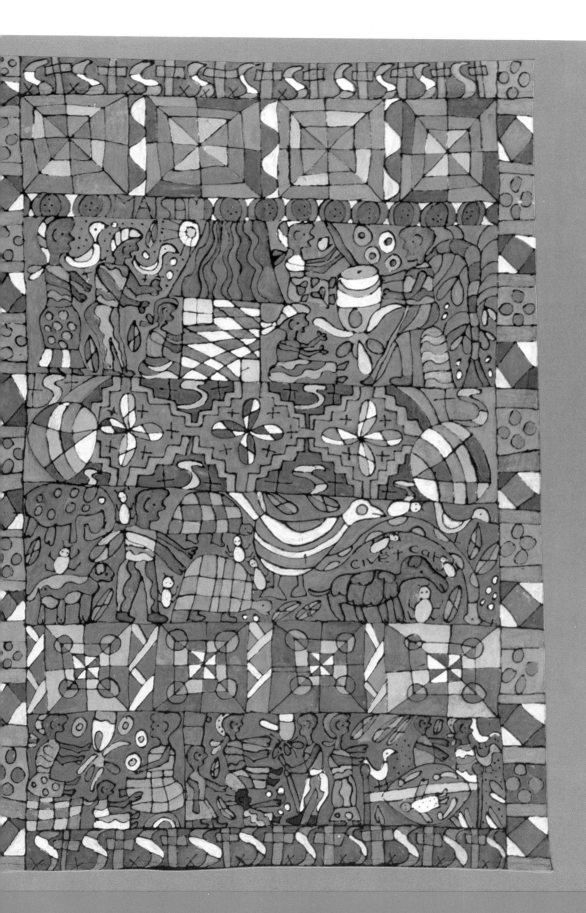

■ How the lizard got a short tail
■ Mavis
■ Painting

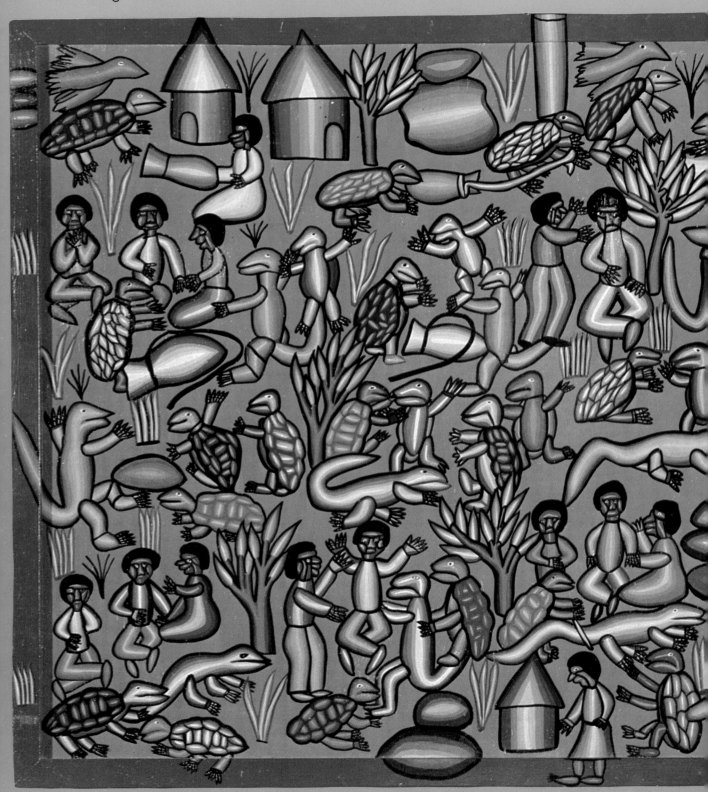

Mr Tortoise thought to go and find something to eat.

Mr Tortoise and his wife were going back home with a sack of beans. When they pass opposite Lizard, he jumps out and sits on a bag of salt. Lizard said he found it on the ground.

The creatures start to quarrel and Lizard said it was the law of the land that anything you find on the road is yours. They thought to go to court where a judge will say who is right. Now they are going.

The elders are sitting and Lizard and Mr and Mrs Tortoise are now in the court and Lizard states the case.

The elders are discussing the case whilst the others are sitting in the court. When they return with the judge, they said the judgement was to share the bag in two; they said that was the judge of justice.

As Mrs Tortoise and her husband were going home they decided to make a plan for revenge. The thought of a nice plan to call Lizard and sing a song whilst Lizard dances and they will hold his tail.

Tortoise and his family are singing a song saying, 'Who is the greatest, Lizard, who is the brightest?'

Mr Tortoise told Lizard to dance lying down and Lizard lies down. Then Tortoise comes out and slowly approaches the Lizard's tail.

Soon Lizard is surrounded by Tortoise dancing and holding his tail. Lizard starts to shout and Mr Tortoise said, 'You know the law of the land, anything you find on the road is yours'.

Lizard and Mr Tortoise decided to go to the court and they are on the way to the elders.

They are now in the court. Mr Tortoise is stating his case: 'I found this object, knowing the law of the land that what you find on the road is yours'.

Mr Tortoise, holding Lizard around his middle, is saying, 'I must cut here in half.' Mr Tortoise reaches for the sword, saying he is going to cut on the waist.

Mrs Tortoise shouts to her husband to cut the tail to save his life and Mr Tortoise cuts the Lizard's tail.

Then Mr Tortoise and his wife go back home. Lizard is crying, carrying his tail back home.

Christian churches

The Apostolics believe in the Holy Spirit and in speaking in tongues. I was once going to the Anglican Church and then I decided to go to the Apostolics. The difference is that the Anglican Church allows everything, like smoking. The Apostolics they don't allow you to smoke or to go to discos or cinemas because, they say, they are worldly things.

My husband and I are attending the same church—we met at the church. It's a problem when a boyfriend is not in the same church because that boyfriend will not know the rules of that church. When there is a church meeting the old *sekurus* (grandfathers or maternal uncles) would go with the boys and the old *ambuyas* (grandmothers or maternal uncles' wives) with the girls. They tell you the manners that you should do and not do.

It's only one wife a man can marry in our church. I haven't seen one divorce. When I have no children? To me I don't think it is a problem. In our church we think children are a gift of God.

I am not Christian; I do not belong to any church. My other family belongs to the Roman Catholic Church but they didn't believe in it. They believe in our Shona custom. The Bible of the Roman Catholics says you should remember your *mudzimu* (spirit of the ancestors) and after that you come to the church. Other churches, like Pentacost, are different. They do not like to eat rapoko because people brew beer from rapoko.

What I mostly like in 'Jonah' are the fish and the waves in the water; I want to show the fish in a story way because I can't just do the fish and the waves. And I put in the waves because, when Jonah was in the boat, God was not happy with what he was doing. That's why I show the waves, which show there was wind. I have seen the sea in pictures.

Whenever Weya artists show the topic 'Enjoying life,' one of the standard scenes within this context will inevitably be 'Going to the church'. Most of the Weya women are members of one of the many Christian denominations in Zimbabwe. Rivalry between the churches, common in Europe, seems not to exist here. Instead people enjoy the service of any other denomination when there is none of their own church.

Most popular are the various groups of Apostolic churches. Members of the Apostolic churches can be recognized easily when gathering under trees or on hills, emphatically preaching to groups of people dressed in long white garments. Men shave their heads and wear beards. Elders especially are allowed, in the biblical tradition, to carry long walking sticks with curved handles. Members of the Apostolic Faith churches are not allowed to drink alcohol, to eat pork or to seek medical help at hospitals, medical doctors or traditional healers. Instead the church's own prophets are supposed to heal diseases and control the social well-being of the members. Polygamy is accepted.

The radical changes in Zimbabwean society and the increasing decay of traditional values leave many people spiritually unsheltered and seeking for new answers. The ones who struggle hardest to find their place in society tend to need the emotional, spiritual and social backing provided by the ready answers and strict rules of churches. Churches like the Apostolic Faith churches are strictly opposed to African tradition (much more than the Roman Catholic Church, for instance). However, they share with the old tradition the magical thinking and the emotional experiences of their members. They seem to be a much easier and more adequate replacement of the tradition.

In cases where the old tradition would leave the individual with an unsolvable problem, the new churches might offer consolation to the person. This might be the case when a woman is not able to have children. In Shona tradition this would be understood as the most severe (physical and spiritual) handicap possible; the woman's life would be considered useless and her spirit would be thought dangerous instead of friendly to the descendants of the family. Such a woman might seek membership in one of the Christian churches, which would give meaning to her life.

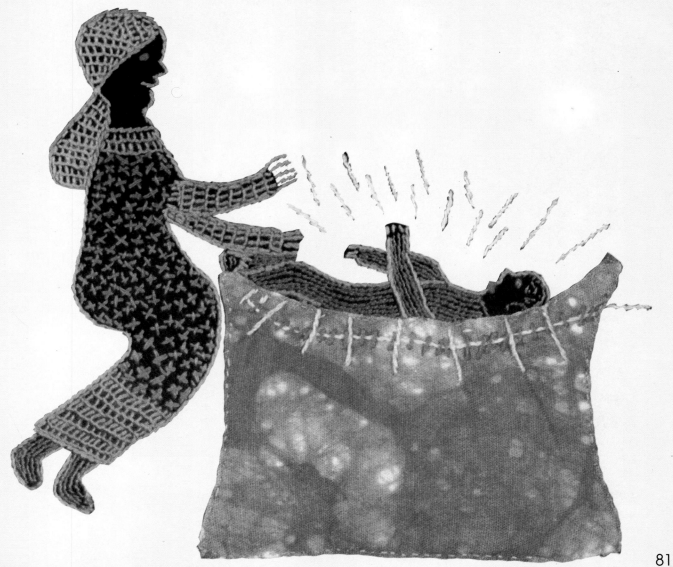

Jonah was sent to Nineveh by God, but he had no feeling to go there; so he decided to go Tar'shish to spread the Gospel of God. He is together with other people in the boat.

God was not happy about what Jonah had done so he sent a strong wind to collapse the boat. All the people in the boat started crying, asking for the matter. Jonah knew the fault and told the people to throw him in the water. He was thrown in and the fish swallowed him.

The fish moved with him for three days, going to Nineveh, the land where God wanted him to go.

The fish vomited him on the land and God made him spread his word to the people. Many people followed him and God was happy about it.

■ Jonah swallowed by the fish
■ Mathilda
■ Painting

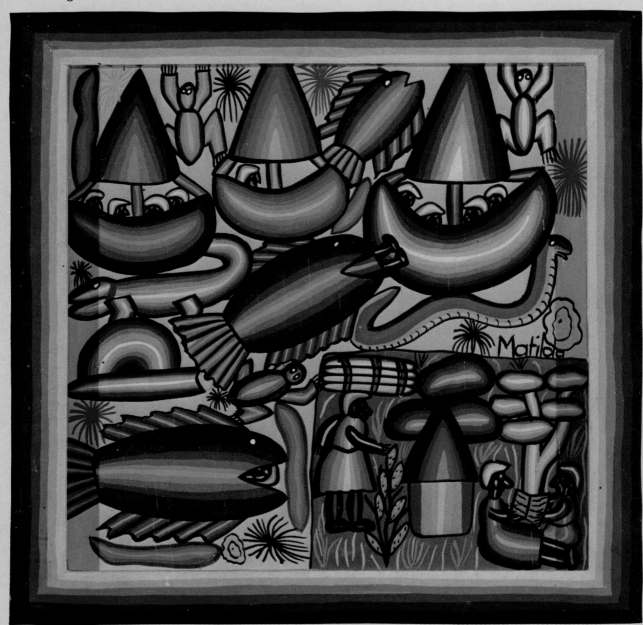

LOVE
AND
MARRIAGE

The $500 *lobola* is being
paid, after the girl has
shown her boyfriend to
her parents.
The aunt is accompanying
the girl to her in-laws.
People are dancing,
welcoming the bride. The
in-laws have to give the
bride money to see her face.
The bride is giving her in-
laws water to bathe and in
return the in-laws have to
give her money.
They are now planning
kusungira. The bride has
to give her first birth
to her parents.
The son-in-law is now
accompanying the bride to
her parents. They are
carrying a hen and they
have a cow.
In our Shona custom the
mother and the daughter
have to step over a belt to
avoid the mother having
back pain.
The son-in-law is now
slaughtering the cow.
The mother and the
daughter are eating the
chicken with the
traditional medicine.
The bride is now
giving birth.
Now people are coming
to congratulate the bride,
giving her presents.
Now the bride is going
back to her in-laws,
accompanied by her aunt.

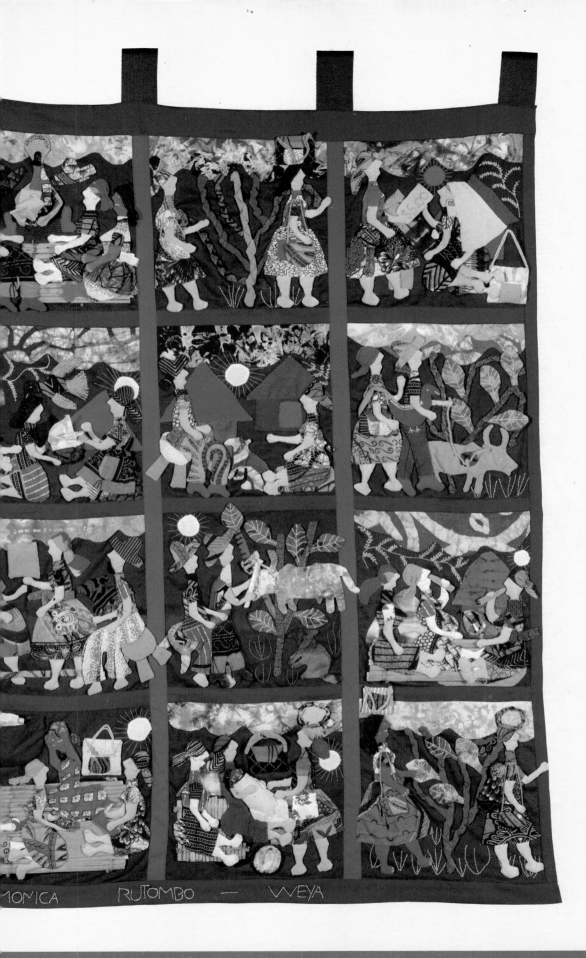

MONICA RUTOMBO — VVEYA

Structures of family life

A person coming from Europe finds it rather confusing to see how many fathers, mothers, sisters and brothers a Shona person has. A European's clear differentiation of relatives into brothers and sisters, cousins, nieces, aunts and uncles, great aunts and great uncles etc. seems not to exist in Shona culture. Instead, it is the position of a person within the context of the whole extended family that matters. This position is determined by the gender and the age of the person. In general, men are more senior than women, elder people have to be respected by the younger ones and are, in turn, responsible for them. Our insistence in finding out the 'real' parental relationship (which is essential in our concept of the nuclear family) is strange to Shona people. A question about the number of 'real' brothers of a person might result in a surprisingly long controversial discussion.

The whole group of Shona-speaking people is subdivided into four main groups: the Karangas, Manyikas, Zezurus and Korekores. The tribes are associated with geographical regions of Zimbabwe, and members of each tribe can be recognized by their regional dialect. The representation of these tribes must be carefully balanced in the cabinet and government.

The *mutupo*, or totem, is much stronger across the boundaries of tribes, tying groups of people together and defining them as members of one family, even if the individuals do not know each other. Whenever Shona people meet their first questions regard the family background of one another. Sharing the same *mutupo*, or clan name, means that the same responsibilities or the same interdictions are valid for the individuals, as would be in a nuclear family. A marriage of two members of the same *mutupo* would be understood as incest, even if the 'real' physical relationship of the two persons is no longer traceable.

In a marriage it is the wife who gives up her totem in order to become a member of the husband's family. But still her ties to her family are very strong and, in case of any conflict, her own family has stronger rights on her than her husband's family. The children, however, clearly belong to his family (see '*Kutanda botso*', the ritual of appeasing a relative's angry spirit). If a woman leaves her husband's family because of divorce or her husband's death, she has the right to keep her children up to the age of seven; then she has to give them to the husband's family. She may stay with the husband's family if she agrees to be taken over by another man of his family.

A traditional marriage is considered 'legal' only when the *lobola*, the brideprice, has been paid (or at least a large amount of it). I have never met a Zimbabwean woman who would prefer to marry without the

My favourite topic is 'African marriage', because you see dancing and eating and the *lobola*. I like it. I would like to get married.

A girl and boy have to go to the aunt for a token. It can be a boy giving a shirt and a girl giving a dress—old ones, but not torn —to prove that they love each other. Sometimes a boy changes his mind and says that she is not his girl, so the cloth is for proof. Maybe sometimes the girl gets pregnant before *lobola* is paid and the boy may say the child is not his. If the boy had given something as proof, like his shirt, and he gets married to someone he didn't give a shirt to, then he has to pay the girl because he was wasting her time. It is a promise. He has to pay a cow or maybe even $3000; the payment is called *mhedzanguva*, that is 'wasting time'.

If the girl does not marry the boy, she has to pay as well. Grace Munhu was in love with a certain guy who was working at a certain store. They were in love for two years. The boy was supporting the girl. Later on the girl was beating about the bushes and then she became pregnant with another man. The boy came to claim all he had been giving her. Since she was not working and had no money to pay him, her parents had to pay a cow.

payment of any *lobola*. A man who does not pay *lobola* shows that he does not esteem the woman. Quite often though, the amount of the *lobola* is so high that to pay it in full is virtually impossible. This causes conflict. The men say to their wives, 'Your parents are eating a lot of money from me, so you must work for it'. The women complain that their husbands don't love them and treat them as their slaves.

The demands for payment of *lobola* from the wife's family put a lot of pressure on the husbands. A young man from the nearby co-operative was truly desperate. When he got married his parents-in-law asked for such high *lobola* that he was not able to pay it with his low monthly allowance. His wife got pregnant. Now she was already three weeks late to deliver. The doctors at the hospital were urging him to agree to a Caesarean, but the parents-in-law refused. (If a woman has to deliver through a Caesarean, the common understanding is that she was not faithful to her husband and the child is not his.) The parents refused because the *lobola* was not yet paid and the daughter was still theirs. Her difficulty in giving birth was thought to be because her husband was not paying *lobola*. If she was going to die, he clearly would be her murderer and face all the consequences (see '*Ngozi*', an avenging spirit). Furthermore, since no *lobola* had been paid, the parents would refuse to bury their daughter (see '*Kuroora guva*', to pay *lobola* for a deceased wife).

Despite all the potential for conflict in marriage, a life outside marriage and family is unacceptable within Shona tradition. The happiness of a person is determined by having his or her own family. A meaningful life does not end with the physical death but is extended into the world of the spirits. One year after a person's death, the second and most important of the funeral rites, called *chenura,* is held. At this time the spirit of the deceased is led to the home of his descendants, thus ensuring protection for the whole family.

People who fail to establish their own families or have children are understood to suffer the most severe physical and spiritual handicap possible. This suffering is believed to be caused either by witchcraft or by an (unknown) wrongdoing of an (unknown) member of the family. Usually the *n'anga*, the traditional healer, is consulted. If he can't help and the person dies, no *chenura* will be held. Instead the spirit of the deceased will be restless and revengeful, demanding compensation for a meaningless life. Precautions have to be taken by the remaining family members against this spirit.

No wonder so many Weya pictures depict marriage and family life within Shona society.

A certain girl had a boyfriend.
One day they went on a
picnic for refreshment.
After that the girl complained
that she was pregnant.
The boy said that she should
go to his home.
She was accompanied by her aunt.
She was welcomed.
The girl gave birth to a baby boy.
The husband's parents were
ill-treating the woman.
Always she was working with her
child on her back.
At last she found that her life
was becoming tough.
She went away to her home.

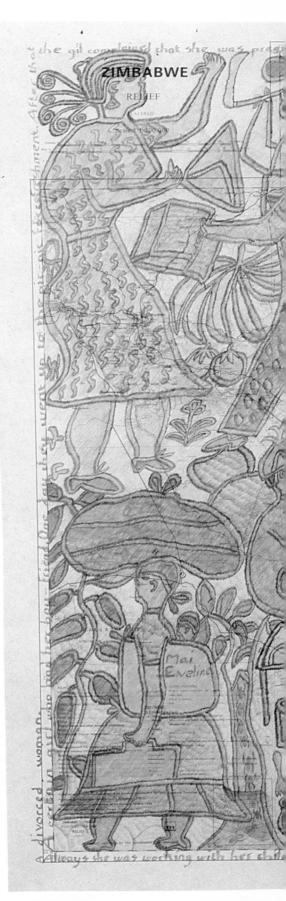

A divorced woman ■
Mai Eveline ■
Drawing ■

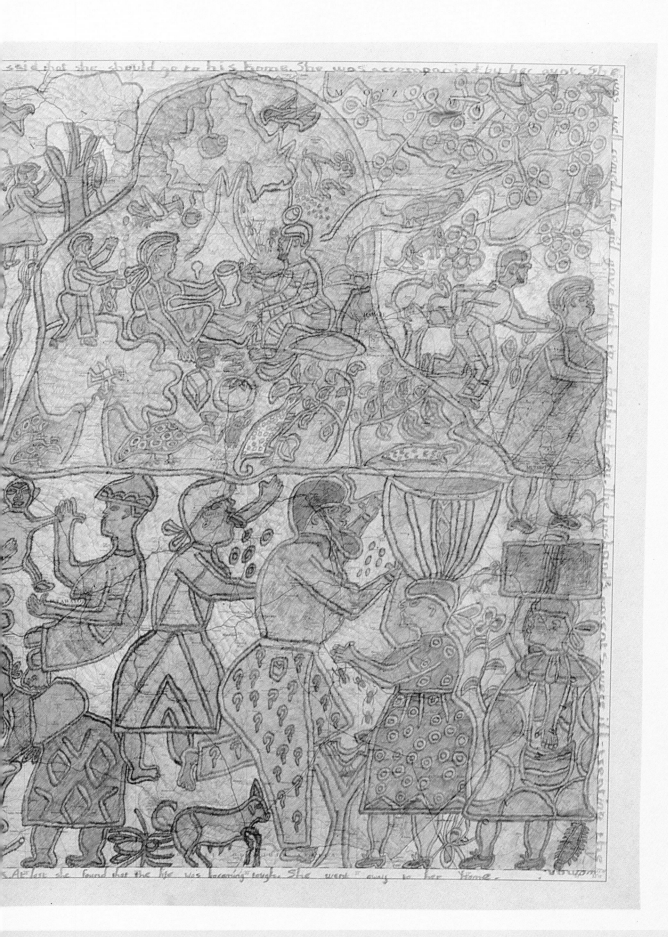

said that she should go to his home. She was accompanied by her aunt. She was ill, could he give milk to a baby. But the husband's parents were ill-treating the

At last she found that the life was becoming tougher. She went away to her home.

The lobola

When a young man and woman wish to marry, he must seek permission from the girl's family. He must also agree to meet their demands for *lobola*, payment to compensate them for their care in raising the woman who is to become his wife. Rather than negotiate directly with the girl's family, the young man seeks out relatives and an intermediary, a *munyai*, to assist him. The negotiation procedures are well established and formalized. Traditionally, the prospective husband gave cattle and token items to the girl's family; today, cattle (or its equivalent) and cash are exchanged. The young man must make token cash payments, the *mavuramuromo*, to the father-in-law, and the girl's sisters and aunts. In addition to the substantial cash payment demanded by the girl's family (*rutsambo*), her parents each receive gifts of clothing, the *zvababa* and

the *zvamai*. After the *lobola* is paid (or part of it) and before the girl goes to her husband, the aunt takes her to her place to teach her how to behave and how to treat her husband.

If a girl becomes pregnant whilst at her actual home, the husband has to pay damages. However, if she becomes pregnant staying at his home, he will pay *lobola* only. Damages consist of between $500 and $1000, depending on the parents. The damages signify that the husband agrees that he is the one who made the woman pregnant. When he wants to marry her, he will ask the parents how much they want for *lobola*. If he does not want to marry her, he has paid everything and he can go, leaving her with her parents. When his child grows up it is his property; he can take the child according to the agreement of the damages.

Kutiza mukumbo — to elope

Kutiza mukumbo (to elope) happens when a girl falls pregnant at her parent's home. First of all she must go to her aunt and tell her about her pregnancy. Then the aunt takes her to the owner of the pregnancy. At the boy's parents they are asked whether they know each other. If he says he knows her and he loves her, then the normal procedure is taken.

Then the villagers are told of the new bride. People dance and ululate for nearly the whole night. Relatives and friends give out some money as appreciation of a new bride. After that, the new bride, with the assistance of her aunt and her husband's sister, gives water to relatives; and everyone smears oil on their faces, arms and legs. After that she is entitled to do all sorts of work, no matter how hard the work might be. The aunt goes back and informs the girl's parents about their trip. Then the man's parents bring *lobola*. That's when the relationship starts.

When I was newly married, it was hard for me, changing from one family to another, from one system to another; but now I am used to it. My husband wasn't working. You know the child needed many things. The money I was earning we used, and the rest I got from the sisters. The manners in the families were different; for example, when you have cooked and you want to take the pot from the fire you have to clap your hands first. I didn't know that—in our family it is not done. They say it is to show respect. You must have something to cover your head and you must wrap that cloth around your waist, the *mazambias* (printed cloth brought by Zambian traders), when you are at home. I knew about it but at our home we didn't do it. At first I didn't do it, but I was told to do it and I followed; I think it is good because it shows respect.

I am married now; I married first December, last Saturday. It was fine. We do not marry in November because our elders tell us it is the month our god was born, and we don't brew beer for the *chenura* or *tsvitsa* (cleansing ceremonies) that month.

In our custom you go to the home of the husband and you have to give the in-laws the water and then you live there for three or four weeks and then you go to your husband. We believe that if you run straight to your husband you are a prostitute. Then *lobola* is paid. He paid a total of $800 in cash. I take $150 from the plate. Most of the money was for the parents. The nine head of cattle is not yet paid for. The father gets seven head, the parents-in-law one, and the mother one. I don't know who the three goats are for.

Mutupo — totems

People are not allowed to marry within the same *mutupo* (totem or clan name); if they do, the child of the marriage will be crippled. If two people of the same *mutupo* love each other and don't want to separate, they look for a white cow or ox and some bark of any tree. They kill the cow whilst the parents of the husband and the wife are gathered.

The father of the man and the father of the wife hold the two ends of the bark over the cow; they cut the bark in two pieces and then they slaughter the cow. They are celebrating now and everyone is eating. And then the two can marry.

But that is not allowed when they have the same father or mother or when the fathers or mothers are sisters or brothers.

If you eat the totem animal, your teeth will rot, you will be toothless. If you eat without knowing it, it will have no effect.

Children

I have three children. After the second born my husband said we should space because we should have children we can look after. Life is expensive. No, I don't wish to have more children, they are enough. I take family planning tablets in order not to get pregnant; no I don't forget.

I have three children, girls only; I would like a boy but it is not coming. I want five children. If God gives me a boy I can finish, I can stop. If I don't get a boy, I can stop. I can tell my husband that he must listen to me because I carry the babies. If I have a boy and my husband dies, I can stay there until I die. If I have not a boy, his parents can tell me to go to my home.

I stayed for eight years without a child; I had to go to doctors so that I could have a child. My husband was my age and he was a farmer from Tanda. When I married we went to Tanda; I was working in the fields and in the vegetable garden. I got a little bit of money through farming. My husband said I could not have children and he divorced me.

My mother-in-law died during the war-time; my father-in-law is a problem. He told their child, my husband, to leave me. I don't know the reason. My husband told his father he couldn't leave me, that I am his wife not his father's. They told him to chase me away home, because every time a child is born it is born dead. Now we are living far from them, so we are living very well.

After grade six I was married. I was 13 years old. My boyfriend wanted to marry me, so for me to continue going to school was a problem. He brought the *lobola*. We had a problem having a child for eight years. We had no children because of my husband—he is impotent. We didn't go to a doctor because the problem doesn't need the doctors. There was jealousy in the family. The family was better off than the other ones, so they thought about looking for some medicine to bewitch my husband.

They thought that when we were going to the *n'anga* looking for a child we were using a lot of money. We had to take all the money from the savings bank to go to the *n'anga*. We went to a *n'anga*, me and my husband, and we were given some medicine to drink for us to get the power. I was pregnant after taking the medicine and the child was born—a baby boy—and then another baby boy was born and then a third one.

If I have no children, I ask first the elder person for the traditional medicine; second I go to the witchdoctor; then I will go to the hospital. If those plans fail I will kill myself. This is so because people believe your name will collapse. If the husband has no children, his property and his *tsvimbo* (walking stick, knobkerrie) and his *ndiro* (plate) will not be given to anyone. If you are the eldest you will not have anyone to live with. If your property is not shared, the dead will not care. But the living, they will not give away the walking stick and the plate of wood. They will share the clothes and the cattle, but the *ndiro* and the walking stick they will not give away. If the dead has a son, they will give it to the first born, but not to the daughters. When there is *chenura* or when they want to chase away the spirit of *ngozi*, the *n'anga* takes that plate from your family and puts snuff in it and they go to a tree and they clap hands at the ancestors and the *ngozi* will go away. Every Shona family has that customary plate.

When a woman dies without having a child, people bury her with a sausage from *mumvee* tree or the inside of a maize cob tied on her back. They say, 'This is your child now'.

If a woman dies without a child she can be *ngozi*. People put a rat on her back and put it in the grave with her and pray that it is her child.

When she is married and has no child there is no *chenura*.

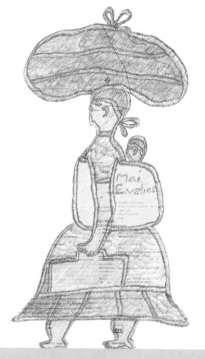

The importance of boys

We believe that when your children have grown up they will look after you. One child only? Maybe he or she will die—even if there are three or four. From ten you will get one who will take care of you. Also if your husband says he wants to have a boy and you have girls and girls, then he will say, 'Let's try', and then it is a girl again and he will say, 'Let's try for the last time' and then I can say I want to have three and I can end up having nine, because my husband says he wants to have boys. If the husband wants boys and she cannot convince him to stop, she will continue until she is old.

I want to have five children: two boys and three girls. When I am too old, my boy can take me and keep me until I die; girls sometimes go to their husbands; she cannot keep me with her husband.

I like girls more than boys. But in our culture it is important to have boys; the boy will be the boss of the girls. When the father dies the boy will be given the knobkerrie to show that he is the boss. When anything happens to the girls, he will be in charge.

In our family we have three girls and the last born is a boy. It is also like that in my husband's family. I like it like that. We believe that if there is no boy when you die, there will be no one to brew beer for *chenura* for you or no one to live with you when you are old. If you have four boys and one girl, each of the boys is given a field and you are left with no field to plough—so it is better to have one boy and to plough and live with him.

I would like to have four children only. Four I can manage to educate them for O-levels. Maybe they can get jobs as a nurse or doctor. All of them I educate the same; it is not more important to educate the boys. A girl never forgets her mother; she will always look after her. When a boy gets married he will never look after her—with a boy you cannot survive. I have three brothers who are married and only one is looking after my mother, the other two never, never. Because they are married, they always answer. They have a wife and children they can't even manage to support, not even a dress, grocery or pocket money. I think their wives forced them not to support their mother.

In former times parents thought that boys should learn more than girls, but nowadays we think both should learn the same. It would be nice if my one daughter could become a teacher, the other a nurse, the boy should go to the shop of the father.

I went to Form 3. The money was just enough for one, so the boy had the chance to go to school. He was not better in school than me; I was better. But it is right. My parents thought that I would get married and support my husband and they would not get anything. I cried and I thought of committing suicide. Myself, I just wanted to go to school. I wanted to work and look after my parents. I was jealous of my brother.

Marriage without lobola

Kuroora guva is a tough situation in African culture. This happens when a girl elopes with her boyfriend and she stays at her husband's place for years. *Lobola* is not paid at all. If this girl dies, the boy's parents have to inform the girl's parents about her death. The parents go to where the girl had been staying as a wife. They do not go straight to this home. The boy's parents are told to pay maybe 15 cattle and maybe $1000 before the daughter is buried. If they cannot afford that, the body will spend many days lying in the house. Sometimes the last solution is to go to the police. If the police are too far, the body can smell. They say it's a lesson to young men who do not want to pay *lobola* there and then after taking someone's daughter.

If a woman dies when she is not married and if *lobola* has not been paid, her parents are called to come to the funeral. They don't really go in where the body is. They will be outside the home and that is where they demand their *lobola*, their *roora* (the brideprice in *mombe* or money). Sometimes the husband might not have anything with him, but they don't care who pays as long it is the family of that boy. The family members have to contribute and that's where they get at loggerheads. They don't want to pay for one who was stupid enough not to pay anything to the wife's parents. But they are forced to pay, because the body is in the house and can even spend two to three days there. If the parents have charged $1000 for the *lobola*, they want it all that day, not $900, and if they charged 10 *mombe*, they want it all that day, not tomorrow. After they are paid the parents go in the house. The parents decide where their daughter is going to be buried; they take a hoe and dig a small hole, that is called *rukau*, which means it is the parents who first dug the grave. Afterwards the body is laid down. After coming from the grave they sleep at the place where their daughter was staying. The following morning they distribute her clothes. After a year or six months, depending on the area, *chenura* is held. A certain type of spirit doesn't allow the husband to bury the wife on his own.

During the war people were sometimes buried when the parents were not around. People say the spirit will rise up, saying it was not buried properly. Today some people are being reburied. Sometimes the spirit lets those people dream about the reason or sometimes it makes family members sick, and they have to go to a *n'anga* to discover the problem.

It happens that a woman gets married and her husband pays some *lobola* of cattle, money, or buys her parents clothes. But she doesn't stay well together with her husband. She might run away. Then the husband's family will go to the woman's home and ask for everything back they paid as *lobola*. If her parents cannot produce those things, the boy's parents start either burning houses or taking chickens and burning them. Sometimes they even burn cords of firewood. The woman's family runs away. If the boy's family does not want that style of *tsvingudzi* (a married woman who has relationships with men other than her husband), they might send a baboon that will clap hands as it enters the home of this woman's parents. It says what it has been sent for. People mostly get quite frightened. Then this baboon leaves the place, clapping hands to emphasize the message. If the woman still doesn't want to go back, her parents have to repay the *lobola* and she must take her children to her husband's place.

A woman is sick. Now the woman is dead. People from the village are coming with water. And two men are going to the parents of the woman who died to tell them about the funeral. Others are coming with maize. Now the parents of the dead person are discussing the funeral. The parents of the dead person are not allowed to go to the house of the dead person. They are allowed to sit in the forest. Now they are at the forest. The husband of the dead person is fetching cattle in the villages. Now he is going with the cattle to the parents of the dead person. Now they are paying *lobola*. Now they are going to the house of the dead person. Others are crying for her child. Three women are weeding the road for the dead person. Now they are carrying a coffin to the grave. They are carrying clay pots for water. Now the people are at the grave. The women aren't allowed to sit there when they bury the dead person.

Kuroora guva ■
Tambudzai ■
Painting ■

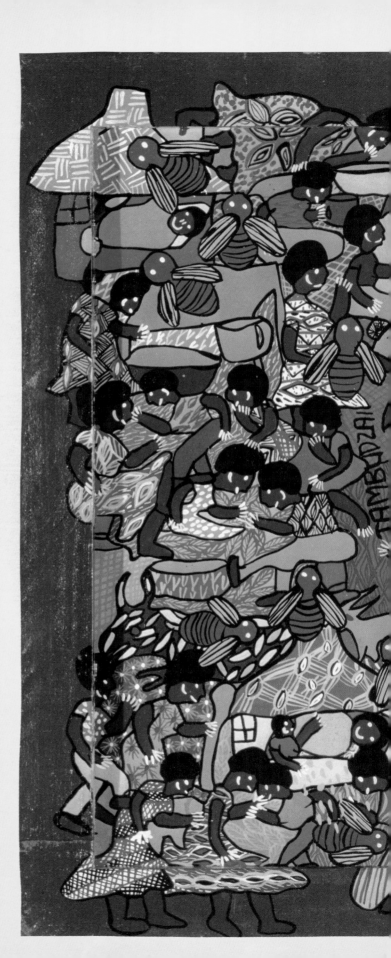

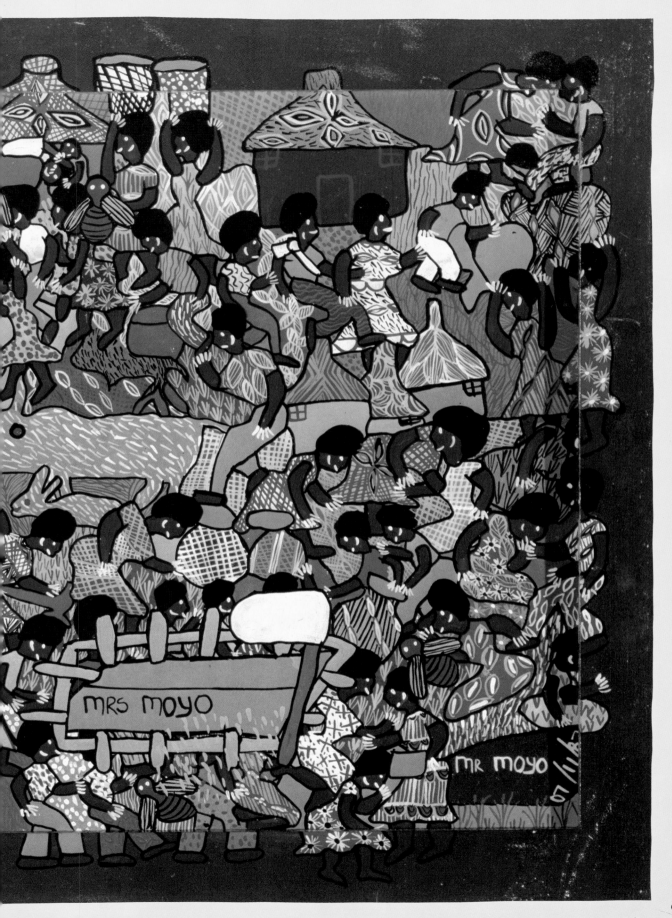

Barika — the husband marries another wife

My mother is the first wife and has one boy and two girls. In 1960 my father married a second woman and she has one girl and six boys. Long ago it was not a problem to have *barika*. People lived nicely, and there was no medicine used between each other. They understood each other and they all went to church, to the same church, the Roman Catholic Church. Nowadays they believe in medicine, in *mupfuhwira*.

When my father married the second wife (Mai R.) I was still at primary school. She went to my *ambuya,* my father's mother, and she stayed there until she born her first child. After that my father built her her houses near to my mother's houses. My mother didn't say anything, or react. I think the second wife is young; she was born in the same year as our first born. We didn't discuss her with my mother. When my father took Mai R., my mother was very friendly to her, because she said it is not her fault. It is my father who is at fault because he lied to her, saying that his wife had already died. So they did not quarrel or anything of that sort. When Mai R. saw that her husband had lied, she started crying. I think there was nothing she could do because she had already a child with my father. She was pregnant when she was in Harare, and when she came she already had the child. He had paid *lobola,* but not all of it. I don't know where she was staying in Harare. My mother knew when he started falling in love with her. She heard from her brother who was staying with my father. She did nothing; she is so quiet. My father he didn't come home. I can't remember for how long he didn't come home, but usually he sent some money for primary school or for food or for the bus. There was no change at all before he took her. I think afterwards there was a change, because at that time both my two brothers were at secondary school and the second wife and the child needed more support. So it changed.

We had a garden at Mupfure River and we ploughed as many vegetables as possible to sell to get money. My father came back here often. He stayed one day with my mother and another day with Mai R. I find no difference in his love with my mother before and after he had taken his second wife. When I am married I don't like my husband to take a second wife. I just don't like it.

If my husband took another wife I would leave the place without his permission. I don't want to be troubled with someone. I have seen enough trouble since my father died. We had a shortage of clothes; we never enjoyed our lives as others do. When we went to the sports we stayed the whole day without food. I wore ugly dresses, because my mother was struggling to send me to school and there was no money left. When some of the children in the villages were wearing nice dresses, we used to run away because we had poor clothes. None of my relatives helped us, not even one. It is a great sign of suffering if a husband marries a second wife. He can't manage to feed two families whilst he is failing with one. I would go without any question. The kids I will leave them or, if he wants me to take them, I will take them. If he doesn't support them, that will be hard, because I know the way we suffered.

Life of Edimore ■
and his two wives
Manuhwa ■
Appliqué ■

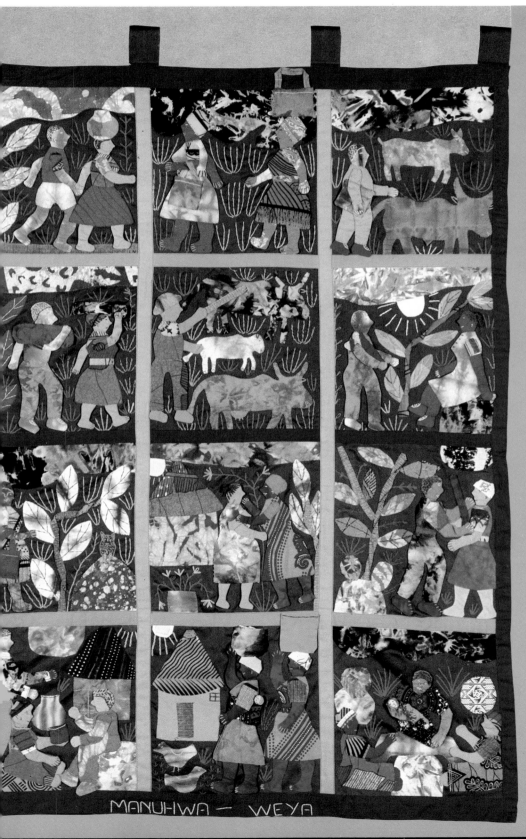

MANUHWA - WEYA

Anna is talking with her boyfriend about their marriage.
Anna and her aunt are going to her boyfriend's home. Edimore's parents are going with *lobola* to Anna's parents: they are taking a cow, goat and money inside the briefcase.
Edimore and Anna are married; they are happy. They are carrying firewood. After one year Edimore is herding cattle in the bush; he saw a girl named Trymore. He talked to her about love and marriage.
Edimore tells Trymore he wants her to be his second wife. Trymore agrees. Now Trymore is pregnant and she is going to Edimore's home.
When Anna saw Trymore coming to her home she beats her and says, 'Edimore is my husband go and find your own.'
Edimore beats Anna and tells her not to hit Trymore, saying, 'She is my second wife and I love you all.'
Edimore and his big wife are at the chief's home. The chief tells Anna not to fight with Trymore.
Now Edimore's wives are coming from the well carrying water; they are talking and laughing.
Edimore and his wives are happy. Edimore is carrying his new baby and talking about future life.

Dying without a child

If the person is not married (and has no child), maybe there is something else in this family causing her to be unmarried. When she dies maybe she will wake up as a *ngozi,* saying 'Why did you not sort out your problem, leaving me to die like that?' The spirit will show by killing the hens and then the goats and then the cattle. It will start with the livestock and go then to the children, starting from the young ones to the elders. But in between, people will go to a *n'anga* and sort out the problem; maybe they can cook some beer and go with the beer to the grave and ask for forgiveness.

There is no *chenura* for one without a child and without being married.

For all in the family it is dangerous to have a *ngozi* in the family.

A woman is carrying poles to build her house.
The woman is holding grass to thatch her house.
They are sitting in the house watching a dead woman.
The woman is buried in the grave with an empty maize cob because she doesn't have any children.

Life of an unmarried woman who has no child ■
Nerissa Mugadza ■
Appliqué ■

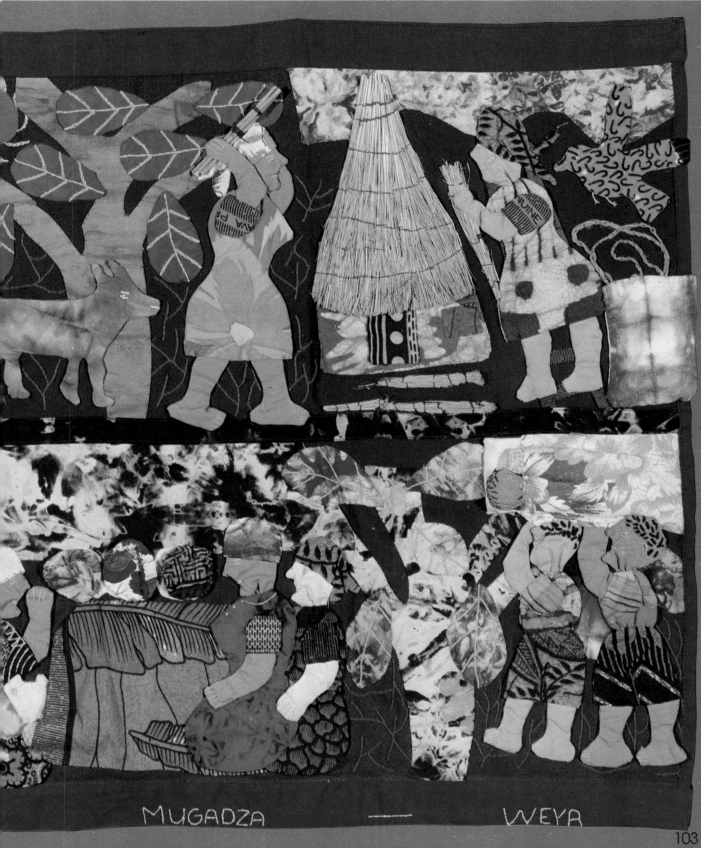

MUGADZA — WEYA

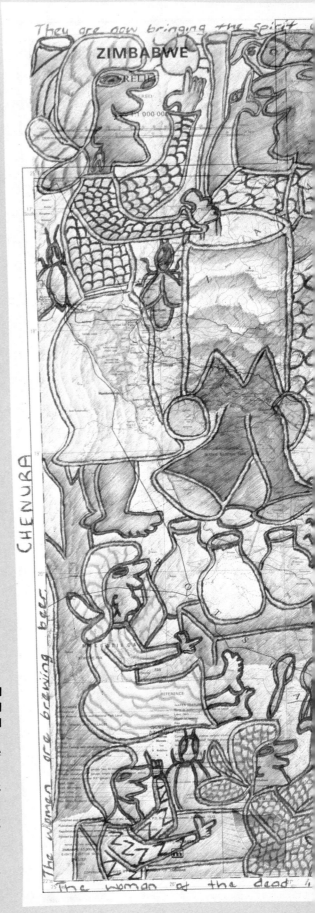

Chenura ■
Sarudzai ■
Drawing ■

The women are
brewing beer.
They are bringing the spirit
of the dead person home.
People are dancing
and singing.
The woman of the dead is
giving the spear to the elder
brother of the dead.

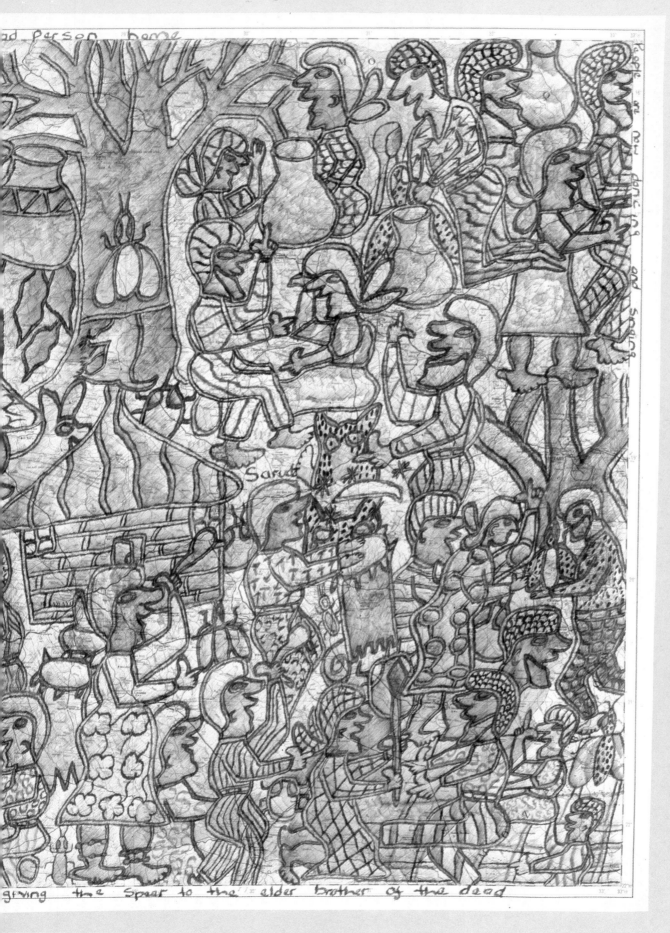

Caring for the dead

Funeral ■
Mildred ■
Painting ■

In our culture, when someone dies we cry loudly to show our loss of this person, whether young or old. Mostly we notify others by drumming drums or ringing a church bell. No matter what time it might be at night, people come to mourn the dead, singing church or traditional songs. The children of the dead slaughter a beast for the mourners to eat. Others, especially men, will dig the grave. Either church or traditional people will be busy sewing a gown for the dead. It is called *fuko*, meaning a cloth he or she wears on top of other clothes. After that the mourners eat. The dead body is then taken to church and then to the grave. Neither the wife nor the husband can see the dead being laid in the grave. Our elders think that if they do, the other one will be taken within some few months. After the burial, people go back home or to the bereaved family. Before they enter the home, there might be some medicine in dishes of water at the gate. Everyone coming from the grave must wash hands before entering this home to clear the bad spirit from the cemetery.

If someone dies in town he has to be buried at home in the countryside; otherwise his spirit would complain, 'Why do you not take me home?'. If the spirit becomes angry it could be a *ngozi*, and people could get sick or go mad. Even young girls might not get married in time or not have children. If this happens, the family has to find out the cause. (Like with some of those people who died in the war who were not properly buried.) When something goes wrong, people have to go to the *n'anga*. He indicates the place where the person died, even if it is long ago. People must then dig up the bones and bury them properly. Or they might only talk to the spirit if they can't find bones. Even if people were in another country, like when people used to work in South Africa and were buried there, relatives had to go there and take some soil from the grave and bring it here.

Mr I. Mudzingwa is dead. Now people are coming to the funeral. He is dead because he was sick. People are bringing some firewood to the funeral and the others are carrying mealie-meal from the grinding mill. As soon as the relatives arrive at the funeral they are tied with a white string around their heads to show that they are the relatives of the dead. The people are now cooking *sadza*, and the others are busy delivering the *sadza* in wheelbarrows. The others are playing some drums for the dead and singing some songs. After eating, they tell the daughters-in-law to weed the way leading to the grave. Now the people are carrying the dead body of Mr I. Mudzingwa and he is buried. The daughters-in-law have to go back home before the others in order to put a dish of water with some leaves called *musosawafa*. They use this to wash their hands and faces. They believe the spirit of the dead may come back to everyone. When they use this nothing will come. The following day the clothes of the dead person are shared and they make plans to go to a *n'anga* to ask the cause of the death, called *kurova gata* (to divine) and they pay a dollar. After that the funeral is over.

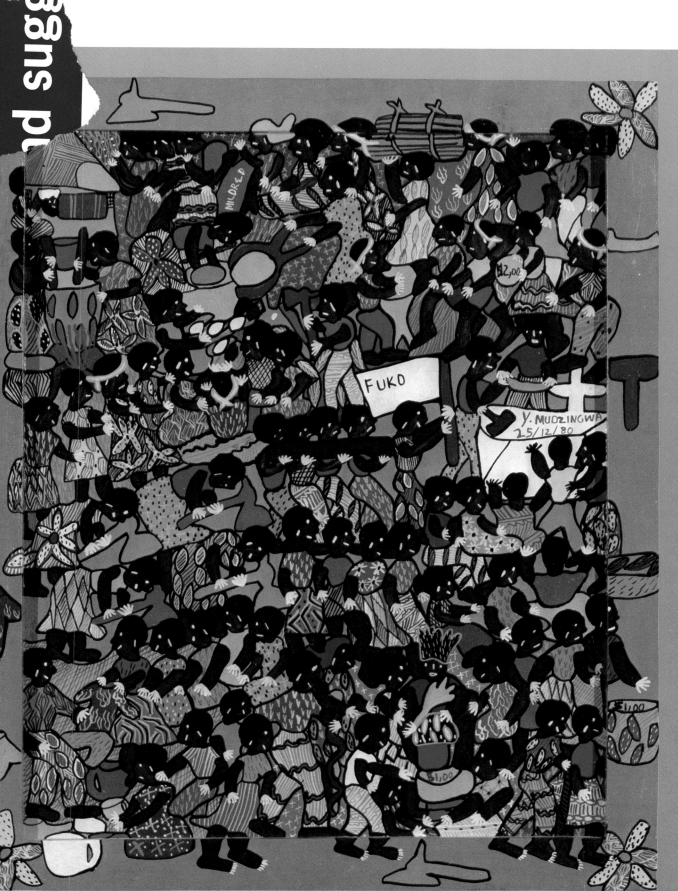

It is believed people have two shadows. The first is the white shadow, the human spirit, which goes to heaven after death. It represents the good part of the person. When the person is dead the black shadow is on the wall near the coffin. When it rises slowly up, the people know that something is wrong. They start asking questions like, 'What have we done to you?' When the shadow goes down then everything is all right, but when it stays up then people have to go to the *n'anga*. Then people can bury the dead. If they bury the person without the spirit being appeased, the person will come back.

There was a funeral for my grandmother some months ago. People went to the *n'anga* to find out who caused the death. The *n'anga* went with them to the hut where he found the thing that caused her death. It was like a rat, but not really like a rat. He asked the people around what they wanted him to do with it. And all said they wanted him to kill the one who used it against my grandmother. So the *n'anga* took the thing with him and now we are all waiting for someone to die.

Chenura is done after the person is dead for one year. Rapoko is allowed to germinate in sacks. When the rapoko is dry, relatives of the dead grind it. The rapoko doesn't have to be ground at the grinding mill, but it does have to be ground with sliding stones. When brewing the beer, women fetch water from the well, not from the borehole. This beer is often brewed by elder women, especially those who do not have their husbands. When the beer is ready, people do not start drinking it until they present the ceremony to the spirit mediums. A beast is slaughtered and the daughters-in-law of that family are given their portion of meat. The other portion is given to the closest relative, like maybe his mother or sister. Meat and *sadza* are cooked and people eat. Before sunset, they start preparing for the ceremony, which is held during the night. People dance and drink beer the whole night. They sing some vulgar traditional songs. This is to ease the tension at the home of the bereaved. Next morning the clothes of the dead are distributed among relatives.

Then the crucial time comes to decide about who takes the wife, if it was a man who died. The wife is asked to sit on the floor with her husband's knobkerries (*tsvimbo*). She is asked to give these to the one she wants to be her next husband. Some new relatives that day will be very smart, wearing ties and suits if they have them, thinking that if they are smart the lady might go to them. If she feels she might want to stay there she gives out *tsvimbos* among the husband's relatives. If she doesn't want to stay, she gives the *tsvimbos* to her *tete* (aunt) or her son. Sometimes the relatives of the husband chase her away, or she voluntarily moves away and goes back to her parents.

My mother supports us with field work; she has never married. She refused even *kugarwanhaka* (inheritance). After the death of a husband, the husband's brothers have to marry his wife. My mother refused. She said I can support my own family on my own. The father and aunt of my mother wanted to force my mother to marry a brother of my father so that she would be able to support the children. At the *chenura*, my mother had a knobkerrie to choose the one to marry. My mother just gave the knobkerrie to my eldest brother. If you don't want to marry someone you give the knobkerrie to your children. In any case, the brother (of the father) acts as my father. If I have problems, I will go to him and he will solve our problems.

MEDICINE SPIRITS AND WITCHCRAFT

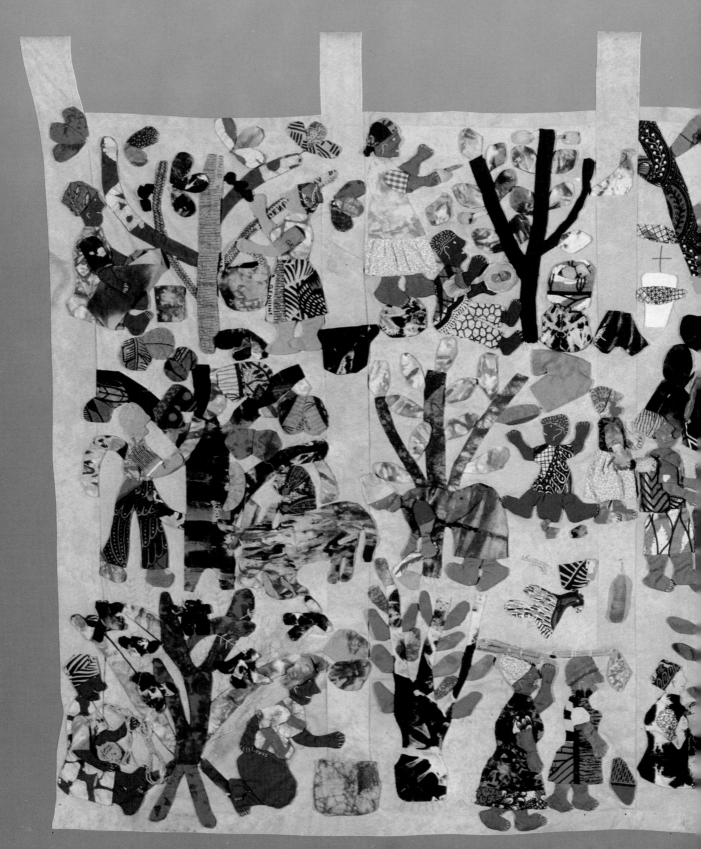

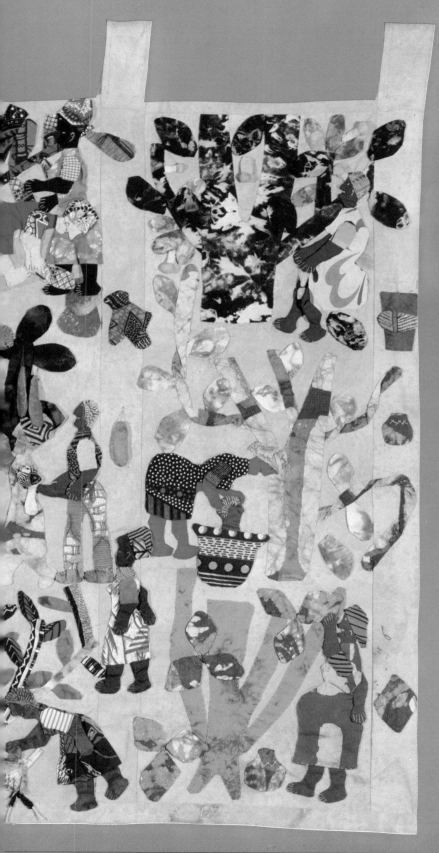

- Trees and their uses
- Mungure
- Appliqué

1. *Mutsubvu* is used to protect against tetanus.
2. *Mubukubuku* fruits are used as food by people and animals.
3. *Mupangara* is used for making baskets and for treating backache.
4. *Mutamba* fruits are used as food and for softening skin.
5. *Mususu* roots are used to cure diarrhoea.
6. *Mupfuti* is used for firewood.
7. *Musosowafa* is used for washing after people have buried the dead.
8. *Mumvee* is used to create swelling in women's breasts and men's penises.
9. *Muroro* is used to treat bronchitis.
10. *Mutunduru* bark is pounded and used for love medicine.
11. *Muuyu* is used to bath a baby.
12. *Nhanzva* is used by pregnant women to ease delivery.

Medicines

There was a boy who wanted his private parts to grow bigger. He was told to go to a certain tree—*mumvee*—and to squeeze his property against the trunk of the tree. He was told to cut the small tree when his property was the right size. But he forgot to cut the tree, and as the tree kept on growing his private parts were growing. That is a true story because the people telling us the story were the ones who saw him. The boy who used the medicine was the one who was wrong, so you can't even say it was the fault of the *n'anga*.

The people who have such big breasts that they can feed their babies whilst they are carrying them on their backs—they have been using *mumvee*. When a woman has small breasts and she wants to have big breasts, she can go to a *n'anga* and he will give her the medicine to go to a *mumvee*. She must sing a song, begging *mumvee* to give her a big breast.

Mutara is another tree like *mumvee*.

For newborn babies

A newborn baby is not allowed to go outside the house without having some herbs from the forest. The *nyamukuta* (midwife) finds the herbs for the baby, and when the baby is born she prepares some of them for drinking and some of them for washing the baby. Some are for burning in the house before the baby can go outside. I am a *nyamukuta* so I use my medicine. Here in Mashonaland they use the skull of a sheep or herbs.

There are older ladies—some are not *nyamukuta* and they do not know the work of *nyamukuta*—but they know the herbs. This small necklace of my little baby is to protect her from any other sickness. You give this type of medicine as long as the baby is young, from one day old to three to five years.

We believe that if a child is not treated with medicine she can be affected when she meets other children. That is why mothers bring children to the clinic for vaccination. I don't know what is stronger, vaccinations

Muti or *mushonga* are Shona words for medicine that describe modern synthetic drugs as well as traditional medicines derived from plants. The Shona understanding of medicine is much wider than the European. I imagine the reason is the different concept of what a healthy person is. In Europe, a healthy person is anyone who is not suffering from a disease. In Shona society, a person is considered healthy when he or she is living a life according to the society's requirements. For instance, even the harsh behaviour of a husband toward his wife is understood as resulting from a disease that can be cured with the right *muti* (see *mupfuhwira*). *Muti* usually has two aspects: physical (to which European medicines are reduced) and spiritual.

or herbs. I never left out the one or the other; I believe they all work.

One medicine is for the fontanelle to close. It is a medicine that we prepare from the fruits of *mupangara* tree; we prepare this medicine when the child is one day old. We burn the fruit and mix the ashes with Vaseline or even cooking oil, and we cover the area with the medicine. Some people use *zinyamhunga* (a tall tree) instead of *mupangara*: the preparation is the same. Another medicine is a piece of bark from *mukamba* tree, which is tied on a string and is worn as a necklace.

We go to the clinic and let our kids be vaccinated. Some say they don't want to go to the clinic. When there is an outbreak of measles, a lot of young children die because they were not treated.

For sex

Runyoka is a certain medicine men use on their women to punish any man the wife has sex with. If somebody cannot trust his wife, the medicine is the way to protect his property. The husband mixes some medicine together with a knife. He puts the medicine around the knife and gives the knife to his wife. It must be a knife that can be opened and closed. The wife is not even aware of it. The husband might put the knife anywhere and ask, 'Mai B, may you give me the knife.' Then the wife takes the knife when it is open and gives it to him. He asks, 'Why do you give me the knife just like that?' And then she closes it not knowing that there is something special on the knife. In our custom it is not good to give someone an open knife, you always close it. That is why she closes the knife without knowing.

When I meet my boyfriend that is when the medicine works, even if the husband is away. That is when people find out: 'This one is treated'. There are different types of medicine. The one with the knife prevents the woman from separating any more from the boyfriend. You meet for good unless the husband comes and does something. He will know the secret of how to do the

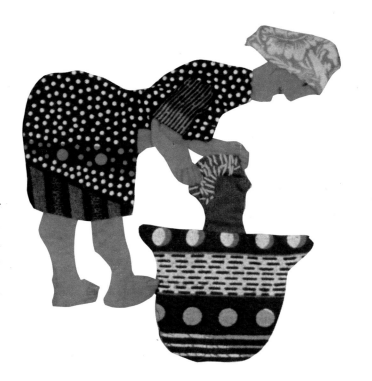

113

separation. Another medicine works after having sex. The boyfriend will lose his penis—it will go inside the body, leaving a small hole only to pass urine. He will know that he met someone who was bewitched by her husband. He has to go to her husband and persuade him to treat him. When the husband agrees he will charge—it can be cattle or money—and after that money or cattle is given the penis will be okay.

If somebody has a boyfriend and they meet, they find out that they are all men. The woman has a penis as well and they cannot have sex together. This is only done with married women.

Sometimes the medicine can only affect the man who meets the treated woman. For example, he can get a very big stomach. Some medicine ensures that if the woman ever meets a boyfriend, the man will die there and then. The elder people know that the woman was treated when they hear about the case. The young people don't know the story unless they are told. If somebody is sick like that it probably means he has done something with somebody.

For husbands

Some women know about medicine that prevents a man from having sex with other women. If he stays with her he will be alright, but he will not be able to sleep with another woman. When it happens the first time he will think he is treated, so he will try for a second time and another time with another woman. He will know that his wife has given him some medicine when he finds he cannot have sex with another woman, only with his wife. If the man finds that the wife has treated him, they both have to discuss it. It is only so in our custom that men do not want to have one wife, they want to have two besides their wife.

The people at Binga have medicine—the man for the wife and the wife for the husband—so that they cannot have sex with anybody else. Before dying the husband can say 'My *muzukuru* (a close relative) can marry my wife.' Then this one can have sex with the woman, but nobody else. That is how they do it.

For love

When I came back from my husband who was treating me badly I was told about *mupfuhwira*. Some people were asking why I did not do that to my husband. Some say *mupfuhwira* is bad, and others say it is right to use *mupfuhwira* on your husband to make him soft. I think it is wrong because I don't want to force matters.

Most African men are harsh to their wives. When the wife gives medicine for love, you see even the harshest men washing napkins, carrying a bucket of maize to the grinding mill, even grinding rapoko at the grinding stone. The wife can even hit him.

In our custom some medicines are given to the whole family. I have six boys and two girls and I want them to love each other and never to quarrel. There is a medicine to put in the food that the whole family has to eat together. Only one person knows, the other members of the family don't know.

People believe that if the wife is beaten every day and treated badly, some people will think, 'Mainini (a female relative) is suffering, what can we do?' They go to somebody she knows, somebody who can help. She gives the husband some medicine so that the husband will become very cool. He will not quarrel any more—and that is when people know the medicine works. Older people know. When newborn babies cry on and on without any reason, without being sick, you find old *ambuyas* who know how to mix medicine so that they do not cry anymore. That is the same with the husband—he will not be harsh anymore.

Sometimes you see someone in a family quarrelling and you think they are going to divorce. Then afterwards you see them okay, they are staying together well, they seem to love each other. So I think *mupfuhwira* works.

I think both can use *mupfuhwira*, men and wives. In our customs it can happen that a husband is having even four and five wives and they stay nicely together and even love each other. The first time there are lots of quarrels because the others don't want to have another woman in the

house. Later you see how they stay nicely together, even love each other. Then you can see he has used something.

Different people talk about different types of *mupfuhwira*. Some use herbs, some other things, it depends on the tradition. Some might use it as medicine for love, some might use it as a poison for someone. **F**or *mupfuhwira* there is a tree called *batanai* (be united). It is a tree that crosses branches with another or has another tree sticking on it. Sometimes you can see it in lemon trees. They make the mixture with the roots, which they mix with water from which a guinea fowl (*hanga*) was drinking. Then the mixture is used for cooking. **I**f a man has two wives, he will give them *batanai* so the wives will love each other. **A**nother one is from puppies whilst they are not yet seeing. *Maranga* is the white stuff you get in the eye when waking up. The *maranga* is put in the food of the man. The woman will be the boss and he will do everything.

Another *mupfuhwira* is made with lizards. Only the tail is taken. You burn it and then take the ashes and put it in the food; that way the man will be just with you.

One disadvantage of giving a man the tail of a lizard is that he follows you, even to the toilet, and he will not go to work for the family. That is a very big disadvantage. **I**f a man was brought to a *n'anga* as a child so that he would not be affected by any *mupfuhwira*, then the wife who tries to give him *mupfuhwira* can have problems. He might beat the wife. Some turn to animals. When he is bathing—only when he is bathing—he can turn into a snake. Or, if the *n'anga* told him that he should not be pointed at with a wooden spoon—and he told his wife all the rules when they married—and if the wife becomes so angry that she points at him with a wooden spoon, then he might turn into a hippo. If *mupfuhwira* is misused, it might work that the husband doesn't love his wife anymore. There are many ways to misuse it because you will be given so many medicines.

Sometimes the topics have a special autobiographic connotation for the individual woman who introduced it first. This was the case with *mupfuhwira*. The painter who got the idea to show *mupfuhwira* in her picture had actually had extraordinarily bad experiences with her own husband before she left him. She showed in her painting a nicer and easier solution to the problem than she had found in reality.

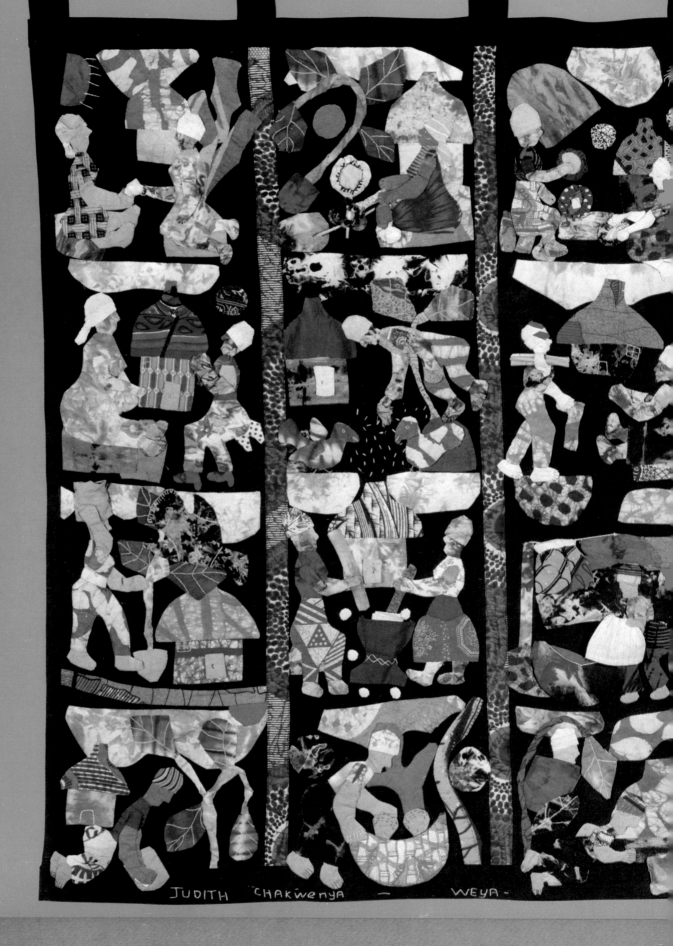

JUDITH CHAKWENYA — WEYA —

116

She is asking for *mupfuhwira* to give her husband.

She is cooking the medicine together with *sadza* for her husband.

The husband is now eating the *sadza*.

The wife is telling him what work to do.

He is now sweeping the yard.

The husband is coming from fetching firewood whilst the wife is just sitting.

He is coming from fetching water.

The husband and the wife are pounding maize.

The husband is washing clothes.

He is grinding groundnuts using grinding stones.

The husband is bathing the children.

The wife is asleep under the shed whilst the husband is painting the house using brown soil.

I saw a man who had been sleeping in the bus on the way from Harare to Chendambuya; he was producing saliva from his mouth and it was running down to his lap. When he tried to sit straight, he collapsed again and the saliva was all over. The wife was neglecting him. She was talking to the husband's young brother. When they were to go off she grabbed her husband's hand and they went down. He was not drunk. It was said by some of the villagers who stayed with them that this husband was given the wrong *mupfuhwira* by the mother of his wife, not the actual mother.

I am very much afraid of *mupfuhwira*. I went and asked for it, but the moment I was to put it in the stew I was afraid and I threw it out. I was given the *mupfuhwira* by the *n'anga* when I visited the herbalist when my child was ill. The *n'anga* said, 'These men of today are too much falling in love with other women; so it is better to give him that to make him steady.'

I do not know how often *mupfuhwira* is actually used, but I guess desperate women quite often experiment with it. Ironically, the belief in *mupfuhwira* is supposed to work in favour of the hard-working women, but it has an opposite effect. The women themselves don't want to be suspected by their neighbours of treating their husbands with *mupfuhwira;* therefore they wouldn't like their husbands to take over parts of the housework. They actually prefer to do it all by themselves.

Spirits

Masvikiro

Masvikiro is communication by the dead. It comes in the form of a spirit through a boy or a girl. Sometimes the boy becomes sick. Instead of taking the boy to the clinic, the parents prefer going to a *n'anga*. That's when they are told that an uncle or *ambuya* would like to stay in this boy-body. That means the dead uncle will be in control of this boy. In order for this spirit to be official, the boy's parents are told to brew beer. Then relatives and friends are told to come and join them in dancing and singing for the whole night. That's when people speak with the spirits through the mediums. The boy who is possessed sits on a mat. Then he talks with the spirit. The elders ask him who he is. He says, 'I am your uncle who died long back. Now I have come to protect you from all evils.' After a couple of hours the spirit leaves him. Sometimes a boy becomes stubborn and would like every member of his family to respect him. This *svikiro* will ask for some knobkerries and clothes, a knife, and a special type of axe.

Kuzvisungirira—Committing suicide

The name means hanging oneself, but it can also mean drinking poison, putting oneself in a dam of water or jumping from a high place. A person who has hanged himself is not allowed to be taken into the house; no one will cry for the dead because it is not a natural death. There is no *chenura* for that person. He is not put inside the house because that spirit of hanging will be around the house and someone else might take the rope he took and hang himself. Cattle will not be killed because if people eat at such a type of death, family members will continue hanging themselves. People are not allowed to cry. The dead person acted cowardly—he wanted to die.

It is not *ngozi* only that cause suicide. It can also be because of problems in the family. If I become pregnant and I go to the father of the pregnancy and he refuses to marry me, then I might commit suicide.

In Shona society, the spirit world is closely interlinked with the physical world of the living. No family can prosper without the protection and benevolence of the ancestral spirits. Should an ancestral spirit be angered and withhold its protection, the descendants would consult a *svikiro*—a person chosen by a spirit as its medium—or a *n'anga* for advice on how to appease the angry spirit.

Mhondoro is the ancestral spirit of a chief and, like the chief, is responsible for the welfare of all the people living in the chiefdom. *Mudzimu* is an ancestral spirit of the family. Each person who has lived a life in harmony within the norms of the society becomes *mudzimu* after death. The *chenura* ceremony welcomes the *mudzimu* into the homestead of its descendants.

Another benevolent spirit is the 'curing spirit'. It selects a person it wants to speak through—not necessarily within families—and that person becomes known as a *n'anga* or traditional healer.

Among the harmful spirits are *ngozi* and *uroyi*. *Ngozi* is a dangerous, revengeful spirit, causing—and is caused by—human disharmonies. *Ngozi* may cause a person to lead an unsatisfactory life or die a sudden, 'unnatural' death. If a person is killed or commits suicide, for instance, or fails to have children, the Shona believe this condition is caused by an emerging *ngozi* spirit or *uroyi*. Such a person will inevitably become a *ngozi* instead of a *mudzimu*. Only a *svikiro* (or *masvikiro*) can protect a person from the dangerous powers of *ngozi*.

■
Kuoma rupandi and commiting suicide
■
Mary Chitiyo
■
Sadza painting

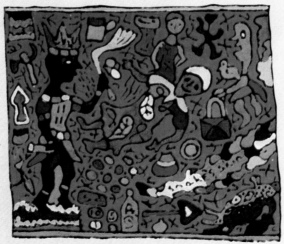

Mr Shumba and his family are busy cultivating their fields. After harvesting he takes some of the grain maize to the Grain Marketing Board. Later Mr Shumba visited his girlfriend with half of his grain cash. News had already spread like veldfire that Mr Shumba was the grain winner of the year, the farmer who produced more bags than any other in that district. His girlfriend had already prepared poison for Mr Shumba to give to his wife as *mupfuhwira*. The girlfriend wanted to take care if the news of their love affair reached the wife. Soon after their separation, Mr Shumba rushed home and he put the *mupfuhwira* in the stew. When his wife ate up the food she fell down, started to vomit and became paralysed. Her dog and cat died soon after eating the remaining food. The Shumba family took the wife to a faraway *n'anga*. There the husband was pinpointed as the one who caused the illness. Because he was afraid of the wife's neighbours and feeling shy with his family, he ran away. He left the children and his wife at the *n'anga's* compound where they stayed for two years. The wife's neighbours, together with one of his working sons, made arrangements to send the mother for dressmaking as she was feeling better and was no longer paralysed. At the *n'anga's* home they left two chickens, a leopard's skin and a snake's skin as payment for healing her. Soon after the dressmaking courses she rented a shop and put her garments on sale. Now here comes Mr Shumba with his girlfriend. He was walking barefooted and his trousers were occupied by grass. At his home no one greeted him, not even his dog; it chased and barked after him. When he saw his wife sitting near the bedroom knitting and never greeting him, he rushed in the bush and committed suicide.

At a certain home the father and his family are discussing whether to kill their herdsman. After some minutes the father took everything and killed the herdsman whilst he was herding cattle. After the burial, they shared the herdsman's clothes among themselves. After a few weeks the *ngozi* started. Cattle died, one of his daughters became mad. The parents of the mad girl went to the *n'anga* to find out how to take the *ngozi* away. They arrived at the witchdoctor's home and were told to brew beer and then take a black chicken and black goats and put them in the forest. When they went back home they did what the witchdoctor told them. They drank beer and beat drums and sent all those animals to the forest. The Apostolic Faith people saw this. They do not believe in *ngozi*. So they took these animals and killed them and ate the meat. But after few hours one of these churchgoers became mad and they could not find a way of curing him.

Ngozi ■
Annie ■
Painting ■

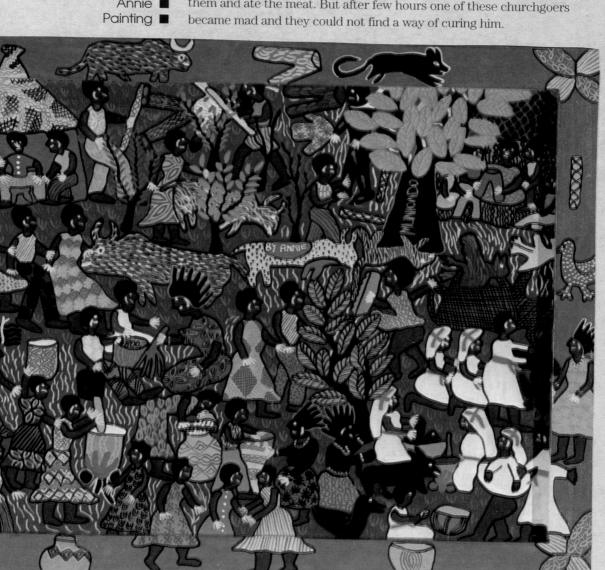

Uroyi — witchcraft

I came to Zimbabwe to start a weaving workshop. After some weeks an elderly woman in the workshop was forced to leave the group because she was thought to be a witch. By that time a young woman, full of self-confidence and obviously respected by the others, was leading the group. Some months later her mother-in-law (whom she didn't like) suddenly died. The atmosphere in the weaving workshop changed almost immediately: the admired leader became the outcast, accused by the others of being a witch, of using witchcraft to kill her mother-in-law. The obvious self-confidence and strength of the young woman were offered as proof, because those qualities could only have been acquired through witchcraft.

The new leader of the workshop who succeeded her was a different type of a person, rather shy, not a 'strong' leader: she felt sick immediately after taking on the post, complaining about sudden fainting, problems with her eyes, legs, arms, headaches etc. Doctors couldn't find any organic causes. Everyone in the workshop was convinced that the new leader was suffering attacks by a jealous enemy trying to kill her with the help of witchcraft. In order to save her health, we abandoned the idea of having the position of such an exposed leader of the workshop at all. Instead, we created a managing committee of five members and that proved to be a much more appropriate solution.

Witchcraft is an important tool within Shona society, guaranteeing stability and preventing extreme social changes. The group protects itself from the rise of powerful individuals through accusations of witchcraft or intimidation of becoming a victim of witchcraft. As a result, people with talents are not promoted and utilized. Instead, individuals with outstanding abilities hide their strength behind other weaker members of a group. In the Weya context it meant that as soon as a woman proved to be extraordinarily talented artistically, she often fell sick, feeling too different from the rest of the group, and believing she was a target for witchcraft.

My experience has been that women are more concerned than men about witchcraft. One reason might be that the traditional hierarchy of Shona society accepted exposed positions for men but not for women. The positions men held were not achieved by individual talent but by structures that automatically made men heads of their families, above women.

A women's weaving workshop within a collective co-operative or a project like Weya Art creates a new type of hierarchy derived from a different—European—concept of leadership, based on individual competency and talent. The step into this new world of individuality and power is bigger for women than for men and probably more frightening. Witchcraft is threatening to the new individuality and, at the same time, reassuring because it provides traditional answers to unknown personal experiences.

When a person is chosen to be a witch she will never have a child. If a child is sick because of the *ambuya's* spirit, it can die and one must then go to a good *n'anga*. He has the task of healing the child and chasing the spirit away. Many things can happen in such a case. One possibility is that the child dies; another possibility is that the *n'anga* will tell the parents to brew beer to welcome the spirit. If the sick person knows that the beer is for her and she refuses the beer, then she will become barren.

When the child dies the spirit can go to another person. When the child accepts the spirit, she becomes a witch. She can even get the property of the *ambuya:* hyenas, snakes, owls and charms. The parents can react in two ways: some parents can be happy when the child welcomes the spirit, because they are afraid that otherwise all other children will die because the spirit looks until it finds one child to stay in. Another possibility is that they refuse to have the spirit with them; they go to a *n'anga* who tells them to get a black or a white (but not an assorted or a brown) goat or a hen, some need both, or even money. The parents first pray to their ancestors at the *n'anga's* place, then they go to the bush and leave the goat or the hen and even the money. If someone comes and beats or kills the goat or the hen or takes the money, he gets the spirit of that *ambuya*. The *ambuya's* spirit tries on the first relative in order to survive.

The *n'anga* prays to the ancestors that the spirit goes to another family. The family must be within the same totem (family); this family must be named (appointed) at the *n'anga's* place.

Witches bewitch their neighbours but also their closest relatives. When the mother is a witch she can bewitch even her husband and her children. The witches are many, they are friends together, and they have their duties to kill because they want to eat. When it is her turn she might even kill one of her children.

A rich woman has a beautiful baby and her enemy does not have a baby. The baby becomes ill and her stomach becomes too big. Her mother and father worry about their baby.
During the war people thought a rich man was supporting white soldiers and the black soldiers kicked him and killed him.
A woman was a business woman who sold eggs; people hate her and she became ill and died.
A leader responsible for quality control judged people's pieces fairly. Jealous people hate him and one of his legs grows big and the other remains small.

Jealousy ■
Judith (Rutombo) ■
Appliqué ■

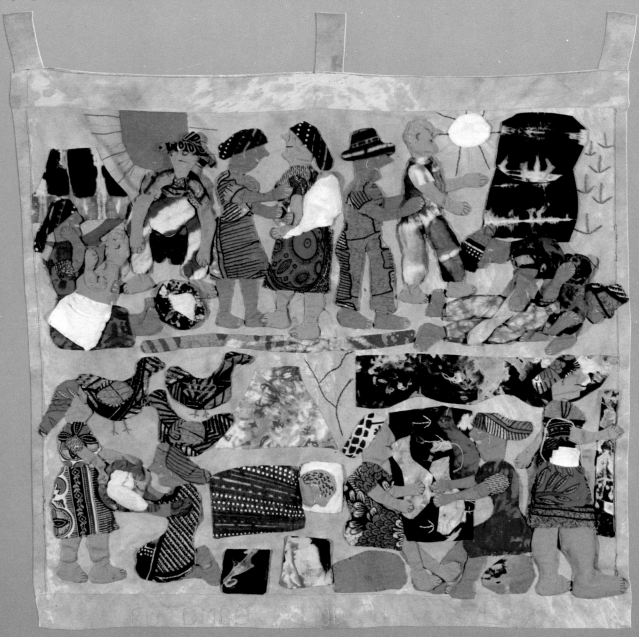

128

When a witch does not like a person, when she is jealous, or when she is not happy seeing you happy all the time, then the witch cuts your hairs during the night or she gives you food during the night or she might come and sit on top of you. You dream you are eating something.

If a husband's girlfriend wants to overtake his wife she might try many ways—something to make him forget his wife or even divorce her and marry her. She will try many medicines; some she will put in the water for mopping the husband's house or pour it in her own body lotions.

I once saw a woman whose husband had a girlfriend. When the wife was visiting the husband in town she stayed at the village—she never met the girlfriend. One night when she was staying at the husband's place she dreamt of the girlfriend. She woke up and told her husband, but the husband said she was talking nonsense. Two days later she was sick. She was becoming mad, behaving as if she were talking to the husband's girlfriend. Then her parents knew it was the girlfriend who put magic there. She came to the hospital for mad persons.

I worked as a housegirl in Harare. A new gardenboy came to the house. He wanted to get rid of me because Madame liked me so much. He brought trays with glasses of African medicine. They made me dizzy and I broke some things of decoration like vases. Madame deducted them from my salary. The other thing that happened was that in the evenings when I was bringing food to the table, bottles would jump up from the tray and hit the Madame.

When something strange happens in a village all the villagers come together and go to the *n'anga*. Some might be pointed out to be a witch.

I experienced witchcraft during the *Chimurenga* (the war for liberation) when the comrades beat the witches. When this one lady was being beaten she started talking about what she would do. She was not talking, it was the spirit. The comrades were beating her and she went into a coma. They thought she would die, but the children of that lady took her to the hospital and so she is alive. Until today she is still doing this job (bewitching). They hate her but they don't show it. Why not? Because they will die.

Witchcraft is also found in the path people use, giving them problems in the leg, some so severe the leg is cut. That is done by men. Lightning is also done by men. Lightning can go into trees and the forest, but when it comes to you then someone directs it.

There was always this type of witchcraft when people were jealous, as in the Bible with Cain and Abel. This type was always in the nation and the family. Other people who are not nationals of Zimbabwe have witchcraft. We can see the difference between the witchcraft that is caused by jealousy and belongs to the country and other witchcraft that is brought from outside.

It is my experience that you should not trust the power of *n'angas*. When you are a strong thinker and stronger in other things and hard working, that is when the medicine and the *n'angas* help. The same applies when you believe in the word of God: when you help yourself God will help you, but he will not help when you are not able to help yourself. If you are not strong, the medicine works for a long time at first, but it soon fades out.

The *n'angas* are after money. Once my father paid a big amount of money and then he found out that the *n'anga* was telling a lot of lies. My father went back and the *n'anga* said, 'When I charge a big amount of money, he will not complain because he wants to be helped.'

Witchcraft cannot work on whites. It is difficult to bewitch someone when you do not know the totem. Whites cannot be bewitched, but they can be poisoned. Witchcraft cannot work on whites because they don't even know about it. We are used to believing in these things, that's why it is not easy for us to neglect it.

I think it is not good to be a leader in a group because many people will try to find a medicine to make him not to be a leader. They will go to a *n'anga* to get medicine and full instructions on how to use this medicine. The medicine is put down on the mat in front of his door. He will be sick and when he recovers he will know that there was some medicine.

After a husband is given *mupfuhwira* he stays with you in a good life and then other people can be jealous. In our custom when people see you have goats and cattle, they ask: 'How and why can it be that he has that,' and then they go to the *n'anga*. You should not say your child is healthy or pretty because then people think this one praising the child is a witch. And when the child gets sick they think the child is bewitched by that person.

Jealousy will always be coming out. If they choose me as a leader instead of her, then she will get some medicine. After that the leader will be tired and refuse to be a leader any longer. When people choose the jealous one to be a leader, she will refuse for a long time, but finally she will accept and know her plan was a good one.

During the war there were the *vatengesi* (sellouts) and those *vatengesi* did not really tell the truth. They would see someone who was prosperous and they would tell the comrades that that man is a witch. The comrades would go to this person's place during the night and kill him and destroy the home.

Some pregnant women don't want to be asked when they will have their babies, because they are afraid the baby will be killed. Most women want to have the child without the knowledge of others. Some without children might like to poison the child. Some neighbours who are not getting on well might kill the child. Or, they might kill the baby in the womb.

When we are pregnant we go to a *n'anga* and he says if he hears someone will kill the child. He gives medicine to prevent the death of the child. The woman has to drink that medicine so that she can give birth properly without an operation. When drinking the medicine, I don't put the cup down but let go of it and let it slowly fall down from my mouth, down my body, until it reaches the floor. If a woman does that, during labour the child will follow easily like the cup, slowly falling out of the body.

It is possible that someone could destroy my eyes by witchcraft so that I could not do the appliqué.

The problem with my eyes started at school. I was together with a girl from my area, but she was an orphan. One day in the dormitory she collapsed and woke up only much later. She told us that she thought she was dead, but then she saw her father who told her, 'You are very bright; therefore, some people are after you to kill you but now you will recover.' I thought someone was jealous because I changed schools and I never suffered from sore eyes again.

If someone has problems with someone who borrowed maize or money and didn't bring it back, then that person could go to a relative and ask him to send *chikwambo* (a hare or a baboon) to the person who has borrowed the goods. Before the *chikwambo* goes, the person who wants the *chikwambo* has to pay something—a cow or money. Then he sends the baboon; it just goes there as a real baboon, but talking. After arriving it sits in the kitchen on a bench and starts clapping its hands. Those who have something from someone know that it is his *chikwambo*. They know something serious is coming, like lightning. The baboon just claps hands in the house and then goes. Those who have borrowed something will act immediately. Some people in the community like to keep those who have a *chikwambo* and others don't. They feel those who have *chikwambo* are witches. They don't like the person who does miraculous things like sending a baboon. They think it is devilish. Some say they bring these things from outside the country, especially Mozambique and Malawi.

Umhondi is buying witchcraft. First a person goes to a *n'anga* and the *n'anga* tells him to kill a person. Then he says to bring him the heart or the liver, even the brain, because he knows what to do with the parts. If the businessman uses the medicine himself, the business may not work because of the spirit of the one whose parts were taken. If the one who was killed is old, the parts will not have much power— that's why they take younger people.

Witchcraft ■
Filis ■
Embroidery ■

The witches are on their way to bewitch their
enemy. Now they are in the house with their
snakes and other properties. The next morning the
person is sick and goes to the witchdoctor. Some
people are bringing firewood and water. The sick
person didn't manage to do well to recover, and
now the person is dead. People are mourning at
the funeral and children are playing outside. Now
they are going to the graveyard. The following
morning, the clothes of the dead person are
shared. The children of the dead person are
covered by a white cloth. And they must go to the
witchdoctor again to hear the cause of death. They
discuss the witches who caused the death. Now
the witches are being chased away from the village
with their properties.

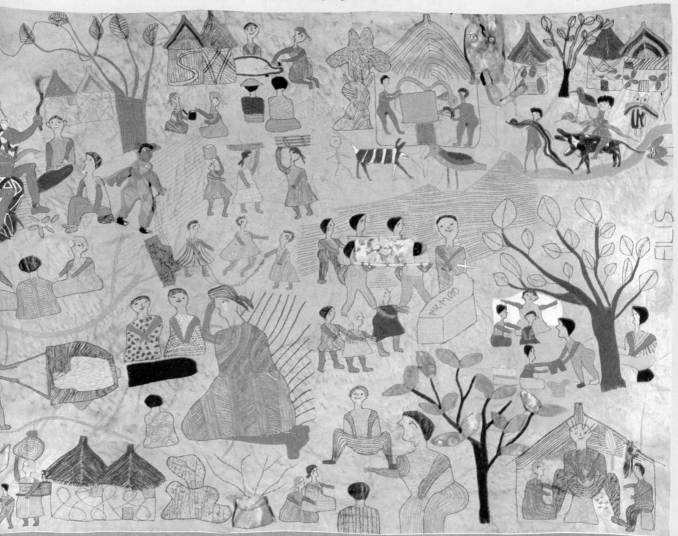

A boy fell in love with a beautiful girl and they are sitting together. The boy went to a *n'anga* because he wants a *chikwambo*. Now he is sitting with his *chikwambo* eating food. The *chikwambo* is sleeping with that beautiful girl. Now the girl feels she was sleeping with someone. The girl's parents are at the *n'anga* asking about their child. The *n'anga* sees it was *chikwambo*. The *n'anga* is burning the *chikwambo* on the fire.

Chikwambo ■
Phoebe ■
Drawing ■

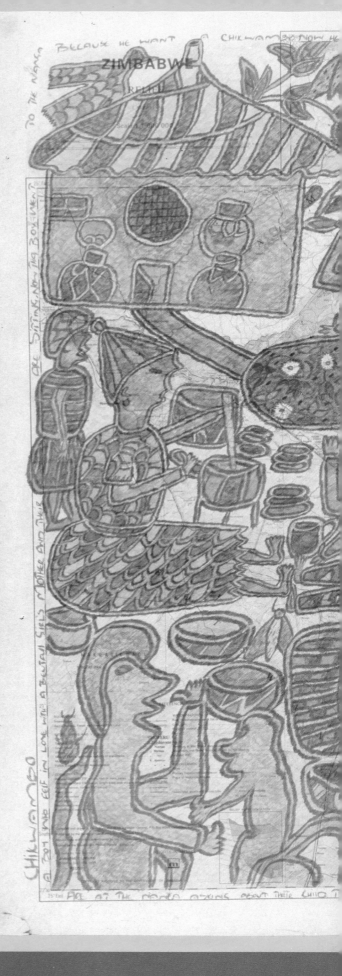

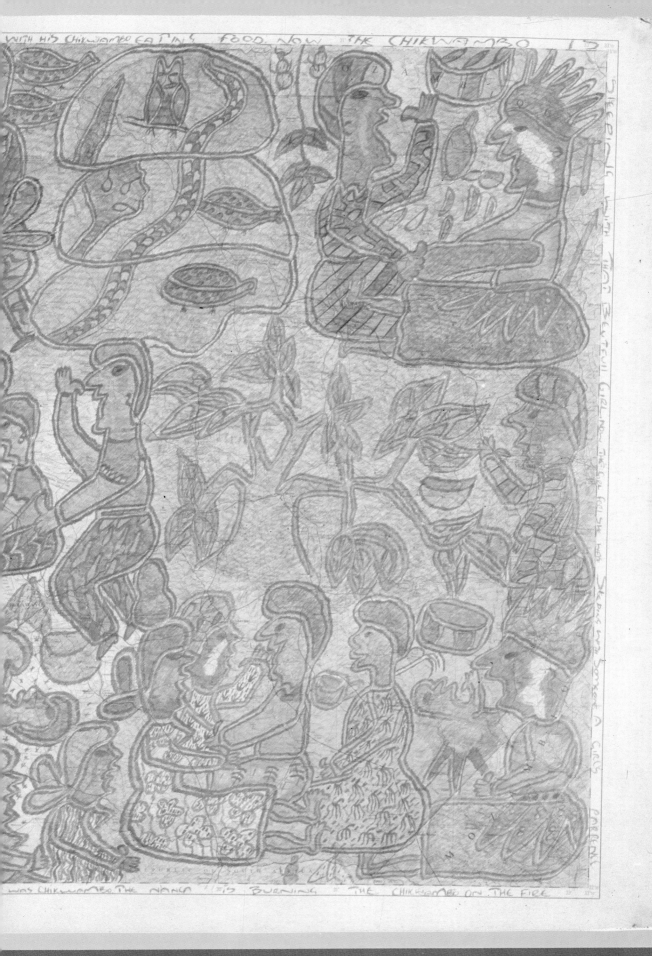

WITH HIS CHIKWAMBO EATING FOOD. NOW THE CHIKWAMBO IS

WAS CHIKWAMBO THE NANGA IS BURNING THE CHIKWAMBO ON THE FIRE

The witches are planning to go to their enemy. They are on their way on their hyena. They treat the enemy. The bewitched is sick and the mother of the bewitched is giving her medicine. Her relatives are discussing whether to go to the witchdoctor. They are now going to the witchdoctor. At the witchdoctor they first pay a two dollar note in order to call the *n'anga's* spirit. The witchdoctor gives the bark of *musosowafa* tree. They are going back home. The sick person is drinking the traditional medicine. Two women are carrying buckets of water. A woman is carrying firewood and the other is carrying a sack of maize. They are going to the other witchdoctor with her in the cart. At the witchdoctor the sick person is in a blanket. The blanket is used to make smoke and spread out in the room. They are going back. People are coming to the funeral. In the hut the bewitched is dead. The mother of the dead is chasing flies away with a white cloth. The son-in-law slaughters the ox. The women are sitting near the hut. The women cook *sadza* for the funeral. They are carrying the dead to the grave. The people are at the grave and three women are washing their faces with leaves of *musosowafa* tree. Now the witches are discussing about taking the body of the dead from the grave.

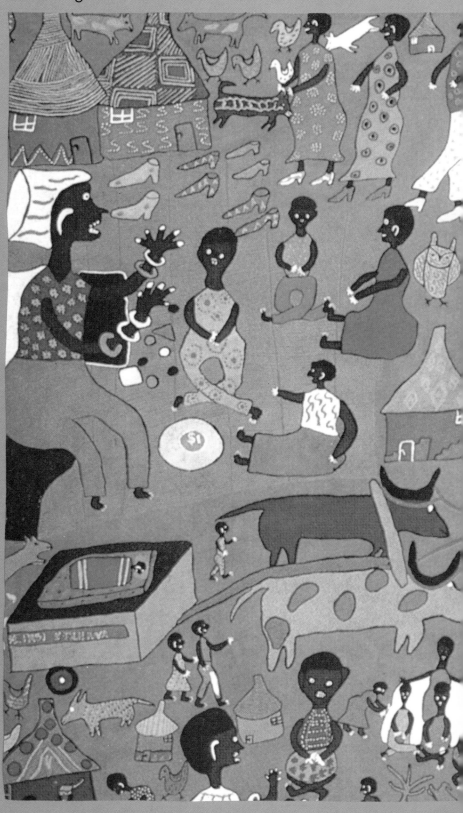

136

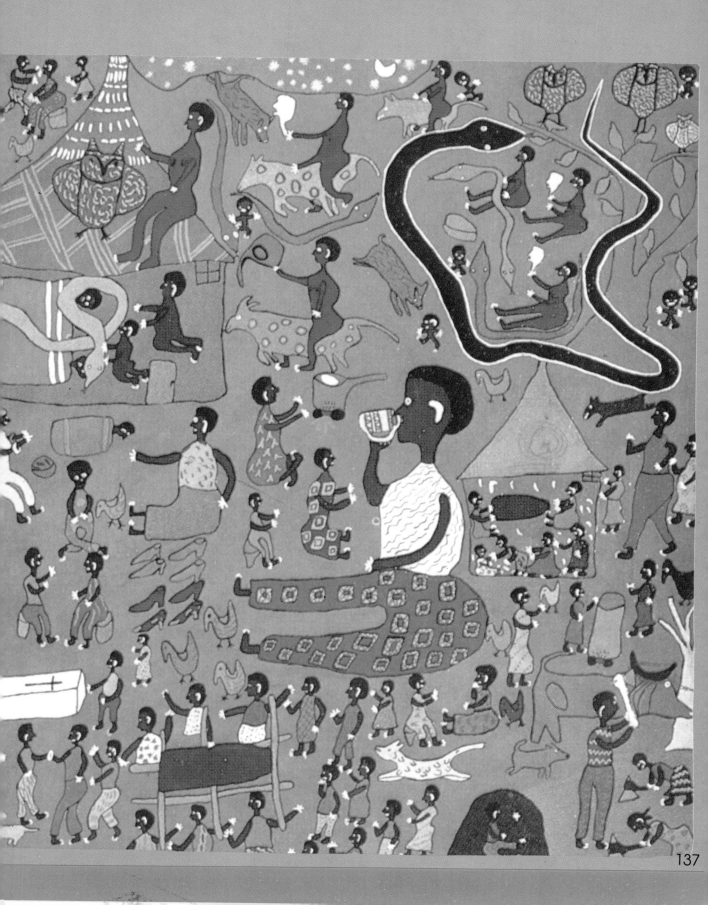

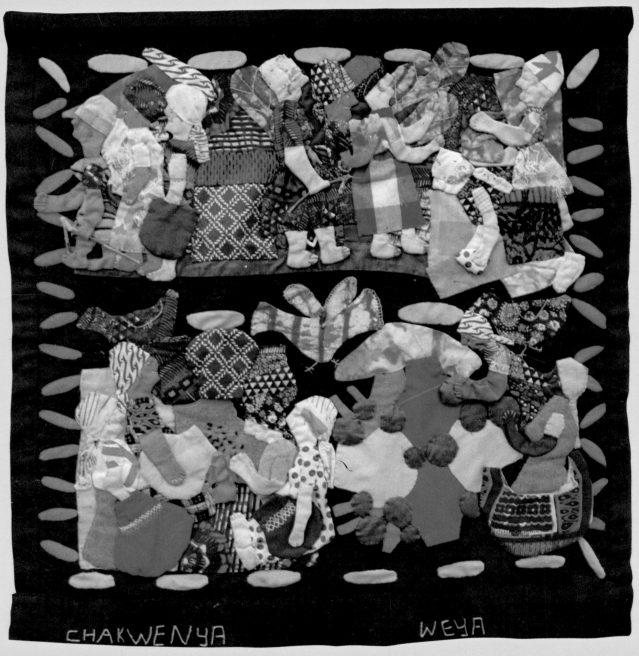

CHAKWENYA WEYA

SOCIAL AND POLITICAL PROBLEM

The Rhodesian soldiers are leaving their camp and are preparing for an encounter with the freedom fighters. Two *chimbwidos* (girls from the villages) have brought *sadza* to the fighters in the bush. As soon as the fighting starts they run home. The Rhodesian army is supported by aeroplanes and parachuters. Freedom fighters attack and defeat a truck with Rhodesian soldiers. When the freedom fighters and the Rhodesians agree on a cease-fire, the freedom fighters come to their assembly points to lay down their weapons.

First Free Election: The people vote for symbols: a cock for Robert Mugabe and ZANU PF, a buffalo for Joshua Nkomo and ZAPU, a spear and an axe for Bishop Abel Muzorewa and the UANC, and a candle for the Reverend Ndabaningi Sithole and ZANU. The cock on top of the ruins of Great Zimbabwe shows the victory of Mugabe in an independent Zimbabwe.

Chimurenga ■
Abishel ■
Painting ■

Independence: People are dancing and playing drums under the Zimbabwean flag.

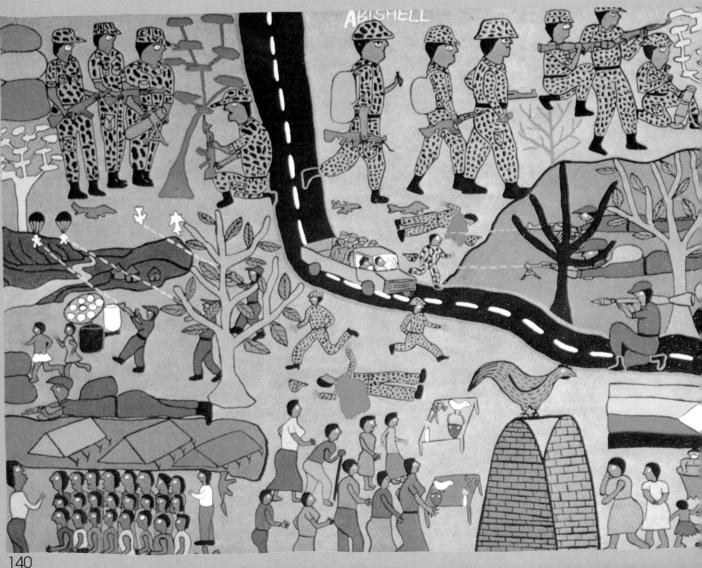

Whilst customers wishes can have a stimulating influence on the women's art production, more often than not the opposite is the case. For the women living in the poor communal areas, life is not as pleasing and simple as the customers would like their pictures to reflect. For instance, any theme that touches on political topics is negatively received. This is understandable from private buyers but hardly acceptable from art galleries. If the women illustrate the different lives white and black Zimbabweans live, the paintings are excluded from art exhibitions and not taken for sale by market outlets. Paintings about the *Chimurenga* are hardly accepted in the official glorious version, not to mention the horrible personal experiences the women endured during the war. Not one of them has ever tried to show her experiences during the war in her work.

Chimurenga

Actually I didn't see it because when it started we didn't see the soldiers. Near our village there was a training centre, and it was not safe for us because it was too near. So from 1976 to 1988 we stayed in Harare. I didn't know what it was all about because I was still young.

I was 17 years old in 1976. I saw comrades coming and telling us to come to the base at Mupfure. During the night or during the day we had to gather together. The girls were called *chimbwido* and the boys *mujibhas*. We had to look for a house in that village where we could cook food for the comrades; then we took the food to the comrades at the base. Whilst the comrades ate sadza, we had to sing *Chimurenga* songs and dance *kongonya*. After eating, the comrades addressed the *mujibhas* and the *chimbwidos* and the parents, telling them about politics. They beat the *vatengesi* (sellouts) and the *muroyi* (witches), who were identified by the *chimbwidos* and *mujibhas*. They also beat the prostitutes. One prostitute was beaten by the comrades because she was in love with the soldiers of Ian Smith and the policemen. She was told to lay down and they beat her on her back, especially on the bottom. I was there.

If the comrades hear that someone is a sellout or a witch, they ask the *povo* (the people) if it is true. If they say it is true, the comrades kill them. Usually when the comrades beat them, they will confess if they are witches. If a witch confesses about her partners and, if they are there, they will also die.

The war started at our place in 1976. Some comrades were at our home, calling us to have a *pungwe* (an all-night rally). In the *pungwe* they tell us how comrades started to move in the areas, about the difference between them and soldiers, and then they sing *Chimurenga* songs. That's when those people they said were witches were killed. It happened between people who were jealous of each other. We saw some who were killed because it was said they were witchdoctors. One was my aunt, and the other was a man who lived in the same area.

The *Chimurenga*, the liberation struggle, ended in 1980 when Rhodesia became the independent nation of Zimbabwe. In Weya, the war had been intense. Probably every family was directly involved. Surprisingly, the majority of the young women around 20 years of age whom I interviewed do not have a clear idea of what the war was like and what it was all about. Perhaps this is because the memories of the others are too horrible. There is a great silence about everything that happened during wartime.

142

They were against my aunt because they said her son divorced my sister. The comrades sent some boys to collect her. She took her clothes and left with the boys. When they reached the comrades, the comrades asked her if she was a witchdoctor. She said she wasn't. And then they killed her. The people were forced to sing a song called 'Rangarira', which means 'the relatives will be crying every time thinking of her'. The villagers were told to bury her and the comrades went away. She had a husband and six children.

My experience with the *Chimurenga* was in 1964 when my father was killed. I can't say by the comrades, I can't say by the soldiers, but I think they were *mujibhas* (those who carried comrades' equipment) who behaved like comrades and who knew something about my father. My father was a teacher and he was killed.

During the night they knocked at the door and my father came out. They said they wanted some money and he said he had none. They knew that he had been given a pension. He told them he had filled in the form but didn't have the money yet. My mother started crying, and they said that they would shoot her. Then they shot my father. Some of the *mujibhas* had guns like the comrades. In the morning a man was passing our house shouting, 'How are you there, how is our meat?' That's why we thought that the villagers killed him.

My parents were killed during the war when I was 10. Those who killed them were called the comrades. The comrades asked them why their sons were working for the government. My three brothers were policemen. I was there when it happened. The comrades came in the evening, they knocked at the door and ordered us outside. Two of my sisters and I were left and the others were killed—my mother and two sisters and a brother. My father was not there; he came the next day. We were taken by the comrades to the headman; I knew nothing at that time. We stayed at the headman's home and then our father came home and found his wife and his children dead. He went to his brother. His brother told the comrades that the father of the children had come. My father was shot dead the next day. It was because he was rich and his brother was poor. His sons got some of the cattle and a fence and all the chickens and everything. Me and my sisters were not given anything. My brothers came and took the children and they buried our parents. Many people were killed like that. Some were rich and some had their children working for the government. My parents didn't know that was dangerous for them. My brothers had no choice but to continue working. My two young sisters and I stayed with my brother.

My father was killed by the freedom fighters because they said he was a sellout, which he was not. They came back again and said they had been told he was a sellout and they beat him to death. Usually someone who is beaten to death will speak out, but he only said, 'I am dying as Stephan who was stoned to death'. He said nothing else. My mother was beaten so strongly with the back of a gun that she did not know what was taking place.

My mother-in-law was killed when all eight of us were sleeping in one room. It was four o'clock in the morning when we heard the soldiers shooting at the comrades. My mother-in-law was sleeping on the floor, and my young sister and I were sleeping on the bed with her five children. The soldier's bullet came straight at the door and hit her near the stomach, the chest and the shoulder. My mother-in-law died, and I was alone and her child was too young.

From 1979 to 1983 we stayed in Harare because it is dangerous at our home. My husband was already in the air force when the war came. We lived in town for five years because the comrades are against the soldiers. In 1980 I was still worried, because sometimes people say they want to kill him because my husband was a soldier.

Equal rights

When a wife goes away from home to do some job she has to ask permission from her husband and she has to accept that. In a case where the husband has paid *lobola* and he asks her to leave appliqué, she would do that because her parents have the money already. If he has not yet paid *lobola*, then he might leave and she would have nothing.

My husband is glad that I am helping him. He is the one who told me to come here. The first money I gave to him, but he says do what you want with your money. On payday I show him the money, but he doesn't take it. He tells me to use it the way I want.

My husband likes it that I do sadza painting because I get money. When I get money we stay together. My husband is happy with that course because I earn more money. My husband is happy with my money, and he does not like me to live far away from him.

When I get married I want to continue painting. We are planning to marry, maybe in August. He has never said anything about stopping painting; maybe he is thinking it. Once I heard his brother saying so, but I have to negotiate with him. I have to try to convince him; even my relatives don't want me to stop painting. In case he will not agree to me painting, I will stop painting.

To expect that my husband will speak the truth to me, ah, no, I will not expect that because nobody will speak the truth all the time. I won't get married before I do a course. In case my future husband does not want me to work? My husband will have found me working and proposed love to me working, so why should I stop working.

Equal rights is really a problem here in Zimbabwe. Some top people, especially top women, insist that there be equal rights. Equal rights at work, that is fine. We go to the same school, we take the same examinations—they are not selected for women and for men. We should be paid the same. That's where I feel equal rights could work properly.

Traditionally the man is the head of the family. The tasks of women and men are clearly defined: hers are home and family, his is public life. He is the one who earns the cash income, whilst the wife has to look after the fields to feed the family. She is supposed to be obedient to her husband.

Traditionally, women need their husband's permission to take on a job and earn money. Usually the woman is allowed to keep her money as her property, with which she will buy household utensils and clothing for herself and the children. But if it happens that a husband feels threatened by the financial independence of his wife, he may not allow her to have a profession. No wonder that in Weya equal rights is one of the favourite topics.

I will tell any boy who wants to marry me that I have a plan. I tell them to wait for me for two to three years. I don't have money at the moment, but I need the money in case of tomorrow. You may be divorced by that man so there is need to worry. I tell him, these days we have got equal rights, so there is no need for me to stay at home without working. If he says I will support you, you do not need to work, I will continue working, because life changes like the weather.

When it comes to the house of two married people, it doesn't work, especially in our African culture. Maybe for those who have adopted western style it might work. But in our culture there are even problems now. I can't imagine my father cooking whilst my mother sits. It is not his area.

Jobs that can be done by women should be cooking, washing clothes, washing dishes—making the bed could be both—but cleaning the bedroom should be the wife, but the men can give a hand. Carrying firewood on the head is for women, but fetching firewood on Scotch carts can be done by men. Carrying the children is for women because women really know how to tie the children on their backs—men have problems. Working in the fields is for men, women and children. Women fetch water, but men can do it with wheelbarrows. You know our men do not like to get commands from our women. If you say today I wash plates, and tomorrow will be your turn, that will be a command. Men do not like that.

Some women submit themselves in order to keep their home. They fear that if they leave they will not stay well outside, and they will put themselves to prostitution. When a man has paid *lobola*, for which he was charged so much, a man doing women's jobs will not work. It will work outside the premises, not inside the house. Women should submit to their husbands.

I do not favour equal rights because a woman was created to do the jobs at home, like washing. It is written in the Bible.

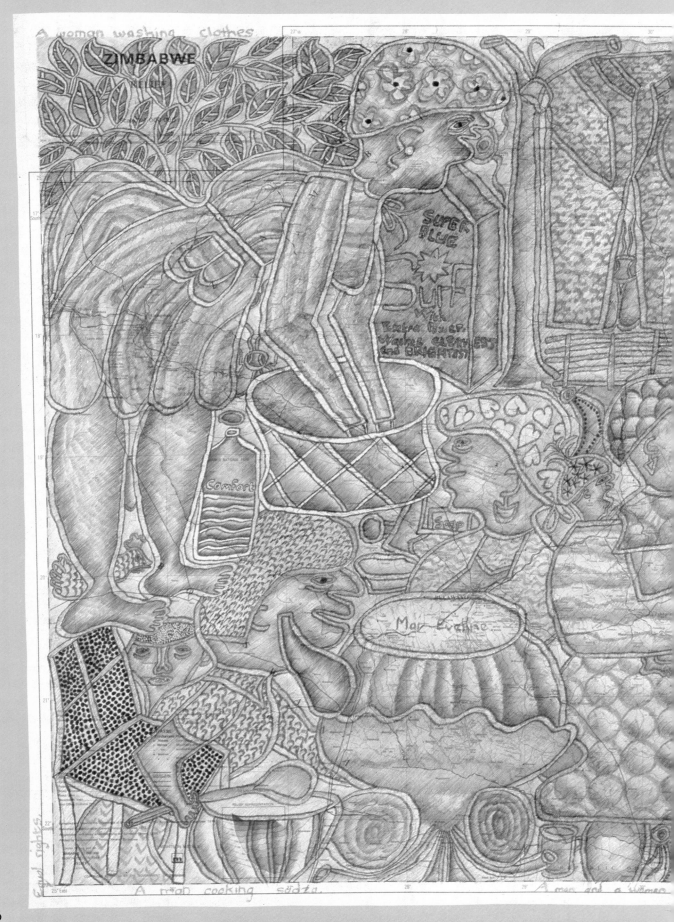

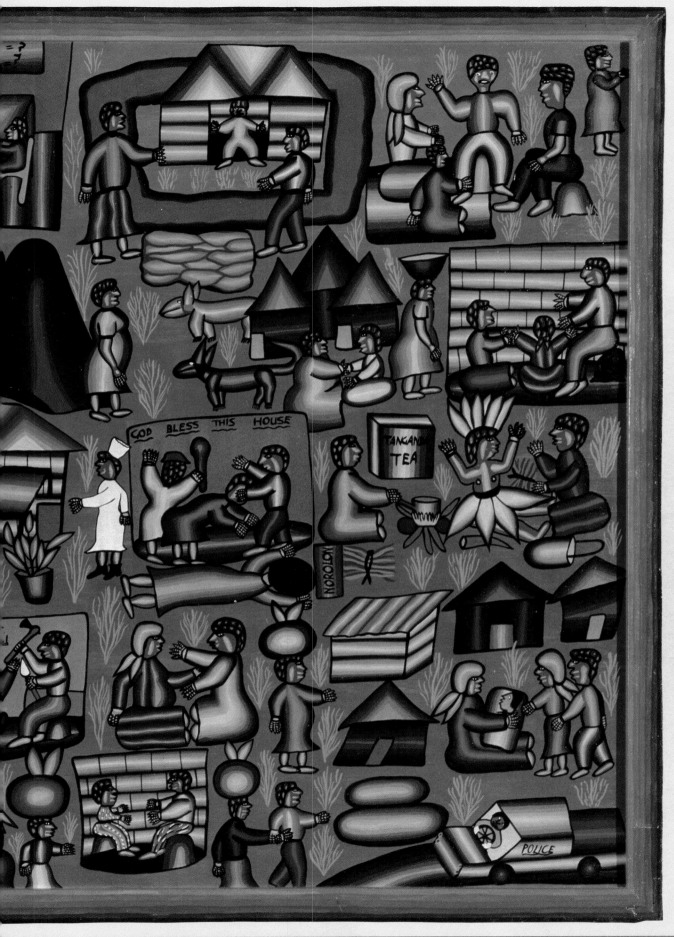

Prostitution

Women turn to prostitution for plenty of reasons. A woman might not bear children and get divorced; one might become a prostitute while she is still at her husband's place because the husband might not support her; or she might have children who die and so remain with no one. Some women do not want to get married because they might feel tied down by family life. Others might have been spoiled (raped) and might have a child. If she was really hurt, she would not want to marry because she doesn't like the behaviour of men. Or, if a man becomes helpless (impotent) because he has other women outside and gets a disease, she might turn to prostitution.

The boyfriends are married men and unmarried men, as long as the person brings some money. A married man doesn't care whether he is put up at his girlfriend's place and does not even care about his wife. Sometimes the wife might not like to sleep with him every time. Men have formed a habit of enjoying themselves outside their home, because they are treated differently. Some women get tired of seeing their husbands every time, and they don't enjoy them any more. It's just the same with husbands too; men enjoy things that are not always open. When a man tries something from outside and finds it to be good, he continues.

Some women who go with men from the bottle store will be given money. They buy soap, sugar, groceries, clothing and they pay school fees. Some give $5; if a man is working he can give $20 for the night. It depends on the men and also about each other. In the communal areas, the majority of men are not earning money and they cannot afford to pay the women so much. In town they pay about $50, maybe $100. When you meet a manager, he earns $1000, so $100 is nothing.

Women who are not married attract men by putting some medicines of love into their vaginas. This medicine is inserted and then washed out before they sleep together. It makes the vagina small, and the man enjoys it. Sometimes married women do not have what women are supposed to have. The aunt, or even the mother, tells the girls that from the

age of eight years or so they have to pull their labia out. We hear that men enjoy it; they play with it during the staying together and it stimulates the two. Some of the married women have only short ones.

Sometimes when a married woman has these problems she returns to her home and goes to her aunt, or even friends or church people, who can teach her how to handle her husband.

In the rural areas, sometimes the wife will go back to her own home because she does not like to stay with a man who has other women. For those who are working and go away, it might be easier because they have a place to stay. The others who are not working might even stay in hedges and wait for men to pick them up, and that will be the beginning of another prostitute.

When a woman is old there is nowhere she can get some money. Her parents and her sons or daughters-in-law will not like her. She will be kept by her brother's children; that is if they want her. She always has to have her own home where she can stay on her own. The relatives will have to build it for her. If she had been used to ploughing she can do her own. Some women leave prostitution when they are 60. They will not know how to plough.

The pill is one method of preventing pregnancies. Another way is to use a plant called *nhanzva*. It is a small tree found in the mountains. You take the roots and put them in cold water and then you drink it from a small mug every morning after playing with your husband (or a boyfriend). It is slimy, like okra, but it has no taste, like water.

After sleeping with a man, some women use a medicine called *mukutura*, which means to clean off, so they won't have big stomachs. (*Mukutura* can be made from *nhanzva* or other shrubs and trees). The medicine is made by pounding a root and putting the powder in a cup with cold water and drinking it. A woman takes it early in the morning after sleeping with a man. It prevents the big belly for those not bearing children any more. Women take it because they still want to sleep with their men; if they don't take it they would have this big belly.

The man is going to work and the wife is escorting him.
The man is enjoying himself with his girlfriend (prostitute).
The man is back home; he is not feeling okay. The wife is giving him food.
The man and his wife are going to the clinic.
The man is being looked at by the doctor to see what is wrong. The doctor finds it is AIDS.
The man is dead; the family is now crying at the grave.

■

AIDS

■

Mai Chakwenya

■

Appliqué

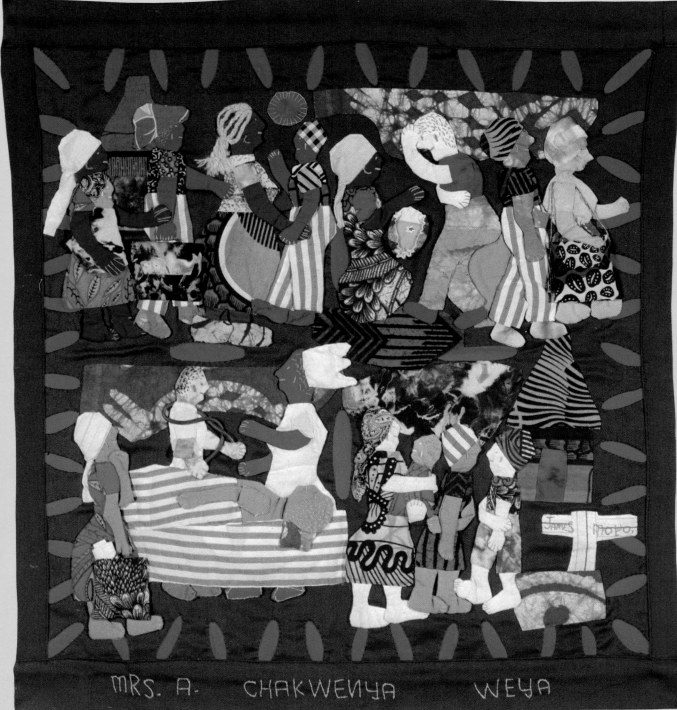

Weya Art and the individual life of the artist

The topics the Weya artists chose as their favourite ones stand in close connection with their personal experiences. These experiences are not expressed directly, but rather they are covered in a story. For example, there is an obvious gap between the actual life of the women who are earning their money by doing art works and the stories they tell in their pictures.

I asked the women what they would think about showing their own life or their own problems directly in their pictures.

Most likely inspired by my interview about the direct appearance of personal experiences in their works, the painting 'Poor becomes rich' was produced. In addition, one appliqué showing the Weya appliqué women was produced as a farewell present when I left Weya. This is the only work of Weya Art that ever tried to show, at least partly, the individual life of Weya artists.

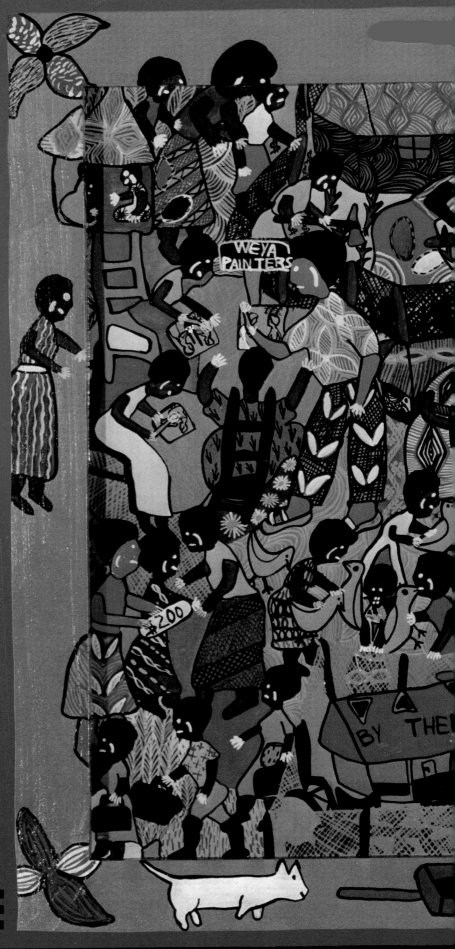

Poor becomes rich ■
Theresa ■
Painting ■

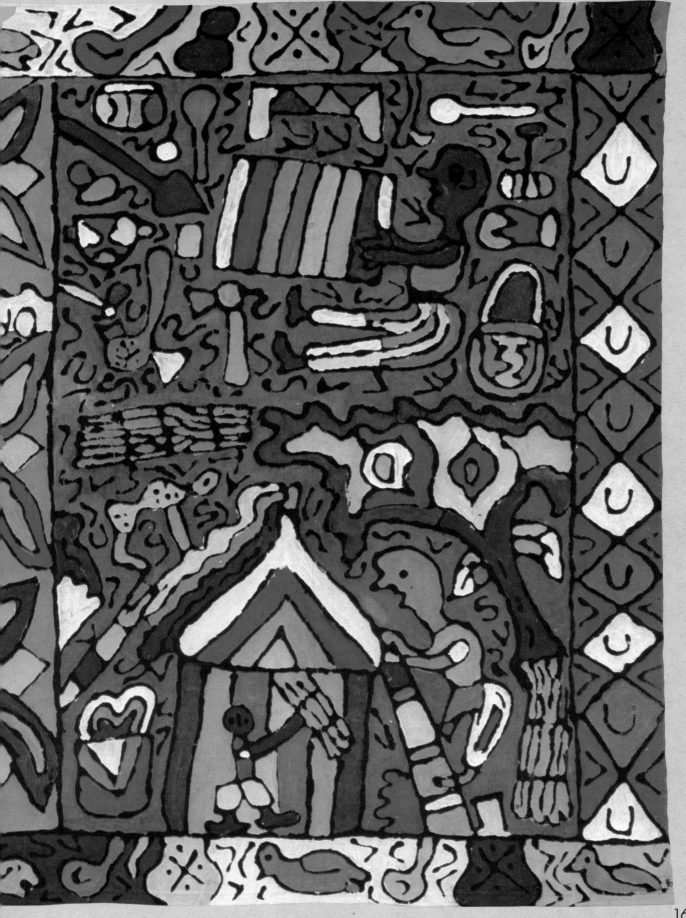

CONCLUSION

The deep feeling of inferiority of their own race and culture still diminishes the self-esteem of many black Zimbabweans. For a number of Weya women, their art has become a step in the their struggle for equality. When they find out from their elders about their culture, it is often the first time in their lives that they have taken their own roots seriously. Weya Art also brings Zimbabwean culture to the attention of the white society, an access individual artists would not normally have. Seeing their own culture being respected in art exhibitions will have an impact on the self-confidence of the Weya women and other black Zimbabweans.

Self-confidence as black women

We used to put on *nhehwe* (dressed hide), now we are wearing dresses, and we are perming our hair. I am black and I want to become white like those whites. I go to the shop to buy 'Amby' (a skin lightener) and my skin starts changing. But this time President Mugabe is against it. He says, 'When you are black, you are black, be proud of your skin'. He is right, one hundred percent right. I have been using 'Amby' since I was a girl. I wanted to be white when I was 17 and 18, before I was married. It was a matter of attracting men because men like beautiful women.

Traditional life interests me because I tell another culture about my culture. In those pictures the people were wearing cloth out of animal skin. I want those people from other countries to know that we are improving. In appliqué we always do something that other people don't know about. We show our African customs in '*Kutanda botso*', for instance, so that people will learn from it. It is important people know what happens to us Africans.

People are ploughing whilst it is dry and with cattle that show they are suffering from not having good grazing. At home a woman is lying outside the house because she is hungry. Now they are sowing the crops. After a few weeks a little rain comes and the maize grows green. Then the rain never comes back and the maize starts to lose colour; the people continue weeding. Cattle are grazing dry grass and some die. Now the government gives them maize and they are very happy about it.

Drought ■
Mai Brema ■
Painting ■

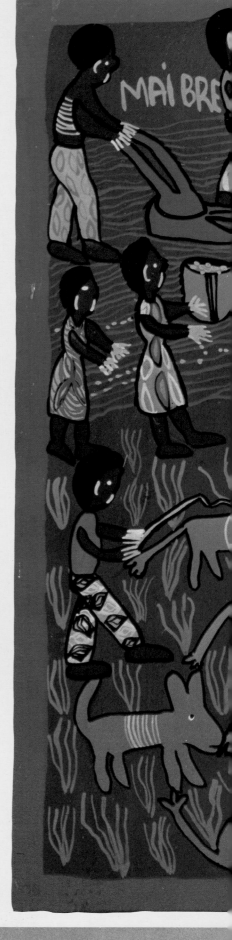

Self-confidence as artists

We don't want men in Weya Art. They will disturb us. Men will always come and ask for help because they are not used to sewing. In painting and sadza painting, it would be good to have men because they know how to draw. Men can draw better than women. I myself cannot draw, therefore I normally go to men so that they draw for me.

For Weya Art it is better that there are women only. But men can participate if they like. In town there are mixed groups working together.

The training centre should be open for men in painting, especially for the three-dimensional type. The type of painting that is done by the Runyange women needs a better type of drawing than the other painting of the women. Mostly, men are better in drawing than women.

David's picture is nicest; it is better than Mavis'. I think men are better drawers than women. David can draw someone just like he appears but in ours you can't see. I don't think we can ever draw like David. We are painting now for three years, and the drawings are still the same. I want to change the drawing but I fail. My auntie's son is a painter, but he has never done a witchcraft picture. He might paint the witch and her property but not the whole story of how she is bewitching the victim. So maybe people are just interested in seeing the whole of a story.

When I was young I didn't believe I could draw something that someone would buy. Now I can shape the body structure of someone. When someone asks me where I work, I say I am an artist. I have written 'artist' on my passport. When I go to Harare, my friends ask me where I am working. I am working at my village, but I am an artist.

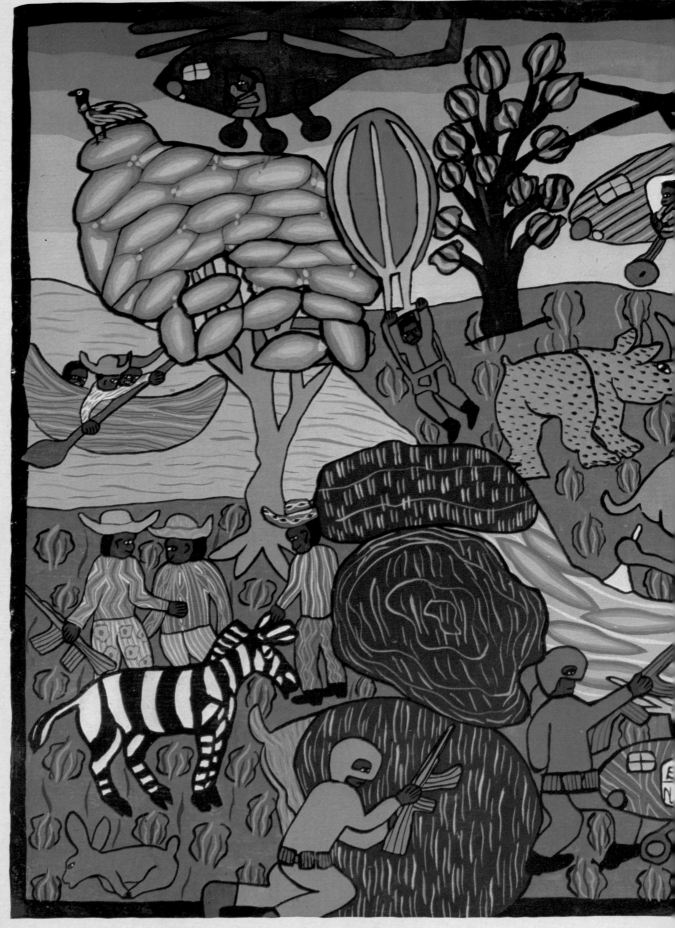

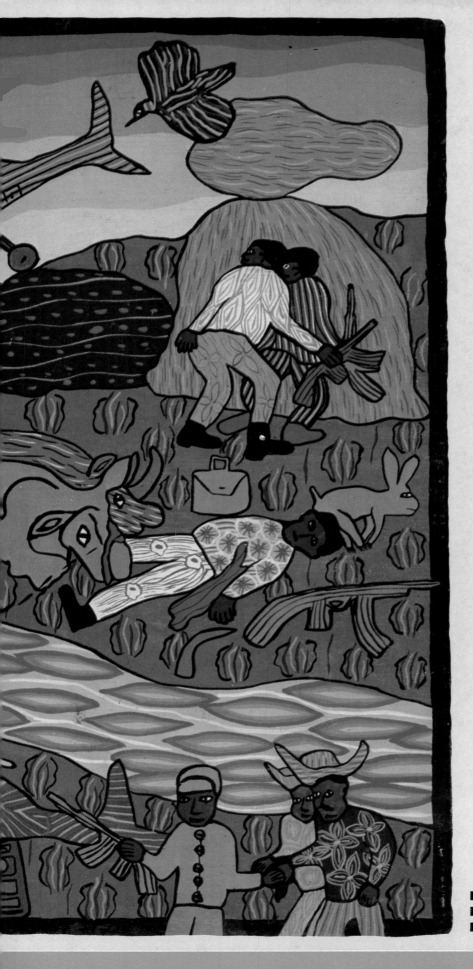

■ Save the rhino
■ Enesia Nyazorwe
■ Painting

The first time I went to the National Gallery, I was astonished. I thought only whites go there. I didn't even think ministers and other big people would come where our pieces were displayed.

My first picture was about transport in Zimbabwe. It went for exhibition last year. The one drawing that won a prize is from Mai E. Many people were there to see the prize winners. This year I got the prize. At Weya, I am the one who won the prize.

My husband was with me at the annual exhibition. On our way home he asked me what I was going to do, whether I was going to paint or leave it. I said I was going to continue painting. He wants me to continue painting because he saw many things at the exhibition and they were expensive. He wants me to continue because when I paint I will have the money, and we will use the money together in our family and we can help together. I think men are the best artists but some of the women are artists. I am an artist but I am average; when times goes by I think I can be as good as a man.

After the opening of the exhibition at the National Gallery, President Mugabe was in the newspaper on the front page. He said long ago we, the Shonas, believed these boards could not be done by blacks or young children. Now we have the technique, and the television and the radio were talking about that annual exhibition. I think it is fine to write a book about the arts and crafts of Weya.

177

Glossary of Shona terms as used within the text

The Shona language uses prefixes to indicate whether a noun is in the singular or the plural. Certain words in the text, for example *ambuya*, *chimbwido* and *sekuru* have been used colloquially and/or anglicized by using 's' in the plural form.

ambuya — grandmother or one's maternal uncle's wife; term of respect for an older woman

barika — a polygamous marriage

batanai — to be united

chenura — cleansing ceremony for the deceased's spirit; ceremony also held to have the spirit accepted by the family's ancestral spirits

chikwambo — animal bestowed with magical powers to seek redress for wrongdoing

chimbwidos — girls who assisted the freedom fighters when they were in Zimbabwe by delivering and serving food, running errands and so on

Chimurenga — fighting in which everyone joins; commonly means a war of liberation, as it does in this text

chipwa — ceremony to pray for rain

fuko — wrapper for the deceased

guvi — depression in a rock in which water collects

hanga — guinea fowl

hwahwa — beer

jenjerere — rim of a bicycle

kongonya — type of dance characterized by front and back movement of the waist and rhythmic jumping

kufamba famba — to be loose, promiscuous

kugarwanhaka — to be inherited as a wife by one's deceased husband's brother or nephew

kuoma rupandi — being paralysed over half the body

kuroora guva — literally means to marry a grave; to pay *lobola* for a deceased wife

kurova gata — to divine

kusungira — The ceremony in which a newly married wife, pregnant with her first child, returns to her parent's home with her husband, the aunts and three goats. One goat is eaten and two goats are presents for the wife's mother

kutanda botso — ritual for appeasing a relative's angry spirit

kutiza mukumbo — to elope

kuzvisungirira — to hang oneself

lobola — brideprice

mainini — one's mother's younger sister or one's wife's younger sister or younger wife.

makandinzwanani — literally means 'Who told you that I have a daughter of marriageable age?'; one of the first payments of *lobola*

maranga — white discharge from the eye that is usually seen on one just waking up

mari — money

marimba — many-keyed musical instrument with a resonator

masungiro — ritual offering made to parents-in-law at first pregnancy

masungo — anything used for tying things

matamba — fruit of elephant orange tree (*mutamba*)

mavuramuromo — literally means 'opening mouth'; payment for discussions on the marriage to commence

mawuyu — fruit of baobab tree (*muuyu*)

mazambias — wrappers tied around the waist by women. Came to Zimbabwe via the Zambia-trade route, hence the name

mbikiza — short traditional skirt

mhedzanguva — literally means wasting time. Penalty paid for making false promises of marriage, paid to compensate a would-be bride for lost time, waiting for nothing

mhondoro — territorial spirit medium, usually a lion

mingoro — loincloth passed betwen the legs

mombe — cattle

mubukubuku — monkey bread tree

mudzimu — ancestral spirit

muhacha — *mobola* plum or hissing tree

mujibha — errand boy, usually means a boy who assists freedom fighters by spying, carrying weapons etc.

mukamba — pod mahogany tree; fruits are used to make beads

mukutura — medicinal herbs taken after sleeping with a man

mumvee — sausage tree; its long, inedible fruit has red flowers that contain a sweet juice

munyai — the go-between in a marriage contract who conveys messages to the suitor and to the future in-laws

mupangara — Chinese lantern tree; type of torn tree

mupfuhwira — love potion given to one's marriage partner so that he/she will love the giver more

mupfuti — Prince of Wales's feathers; known for its high yield of string

muporepore — powder from the fruit of a baobab tree

muroro — wild apple tree

muroyi — witch

mushonga — medicine

musosowafa — type of tree whose leaves are used for washing after burying the dead

mususu — 'mangwe'

mutamba — elephant orange tree; fruits (*matamba*) are hard and round

mutara — wild gardenia tree

muti — literally means tree; within this text it means medicine

mutserendende — sliding game played on a slippery rock

mutsubvu — chocolate berry tree

mutunduru — African mangosteen tree; fruits are bitter

mutupo — totem

muunze — mountain acacia tree

muuyu — baobab tree

muzukuru — nephew or other close male relative

n'anga — traditional healer and diviner

ndakarova mai — I beat my mother

ndiro — plate

ndiro yemuti — wooden plate

ngano — folk tale or folk tales

ngozi — avenging spirit

nhanzva — soap bush; found in hills and mountains

nhehwe — dressed hide

nhodo — game similar to jacks

ninga — cave

nyamukuta — midwife

povo — term of Portuguese origin for the ordinary people, the masses

pungwe — nocturnal political meetings held during the liberation war

rangarira — to remember

roora — acquire a wife by Shona custom

rukau — first digging of a grave by a relative who has the same totem with the deceased

runyoka — charms to punish a man who commits adultery with a married woman; the resultant venereal ailment has the same name

rutsambo — part of *lobola* paid in cash today

sadza — thick porridge prepared with mealie-meal

sekuru — maternal uncle or grandfather; respectful way of addresing an older man

svikiro — ancestral spirit medium

tete — aunt; one's father's sister or one's husband's sister

tsambamaropa — literally means bathed in blood; drum beaten to signify death

tsvimbo — walking stick, knobkerrie

tsvingudzi — married woman courted by other than her lawful partner; legal case concerning broken betrothal or marriage agreement

tsvitsa — cleansing ceremony held to have the deceased's spirit admitted in the ranks of the family spirits

umhondi — murder

upenyu — life

uroyi — witchcraft

vatengesi — sellouts, betrayers

zinyamhunga — prickly salvia; a tall tree that provides herbs

zongororo — millepede

zvababa — literally means 'for father'; brideprice items payable to the father-in-law

zvamai — brideprice payments to the mother-in-law

Weya

Below this you will find the names of the women in the order in which they appear in the photographs on page 4.

Conny (Manhuwa)	Rosemary Zinyuku (Mugadza)	Mathilda	Mai Sam	Mai Rita
Judith Karua (Rutombo)	Mai Blessing (Mungure)	Nerissa (Mugadza)	Mai Evelyn	Susan (Chakwenya)
Nester (Runyange)	Tima	Mai Benji (Kushinga)	Phoebe	Mai Mugadza
Agnes Shapeta	Mai Patty	Anna Kamwendo (Chendambuya)	Mai Kundunga (Kapiya)	Mai Chihururu
Mai Desderio	Mai Matimati (Chendambuya)	Mai Dzomba	Filis	Mai Tima (Mukute)
Mai Moto (Mukute)	Mai Bonongwe (Kushinga)	Rose (Mungure)	Melania	Mai Zinyuku (Kushinga)

The work and the views of the following women appears in the book, but they were not available at the time the photographs were taken.

Painting: Theresa Mungure, Annie-Grace Mambudzi, Naomi Mudzingwa, Lizzie Mungure, Tambudzai Musengeiwa, Mildred Mudzingwa, Evangelista Mungure, Filis Bonzo, Lizzie Jane Musariri.

Drawing: Sarudzai Mudzingwa, Milkah Musengeiwa.

Sadza Painting: Mai Chirubva, Mary Chitiyo, Stella Mutimbanyoka.

Below you will find the names of the women in the order in which they appear on page 5.

Mary	Mavis	Abishel	Mai Noel	Mai Marvellous (Makute)
Mai Alexious (Mukute)	Jane Karau	Beauty		Mai Chigondo (Kumboedza)
Enesia	Mai Makota (Mugadza)	Mai Mashonganyika (Mugadza)		Mai Brema
Mai Nester (Rutombo)	Mai Never	Mai Tawanda		Mai Zvimba (Kushinga)
Loise (Mungure)	Mai Yasin	Mai Charity		Mai Chakwenya
Mbuya Gudza (Chakwenya)	Mai Stanley	Judith Mavhurume (Chakwenya)	Mai Katesi (Chendambuya)	Ella Maramba (Zvaramba)

The work of the following women appears in the book, but they were not available at the time that the photographs were taken

Appliqué: Mai Peter (Rutombo), Mai Chikonodanga (Manhua), Prisca Mambudzi (Mugadza), Mai Mudzingwa (Mungure), Mai Lernmore (Kumboedza), Mai Chikoore (Mukute), Mai Chakwenya (Chakwenya)

Embroidery: Mai Chekacheke.